why dogs are better than cats

BRADLEY TREVOR GREIVE

photographs by Rachael Hale

**Andrews McMeel
Publishing, LLC**

Kansas City · Sydney · London

09 10 11 12 13 TEN 10 9 8 7 6 5 4 3 2 1

Library of Congress Cataloging-in-Publication Data

Greive, Bradley Trevor.
Why dogs are better than cats / Bradley Trevor Greive.
 p. cm.
ISBN-13: 978-0-7407-8513-9
ISBN-10: 0-7407-8513-3
1. Dogs—Miscellanea. 2. Cats—Miscellanea. I. Title.
SF426.2.G73 2009
636.7—dc22

2009014624

www.andrewsmcmeel.com
www.thelostbear.com

Photography by Rachael Hale
Design by Gayna Murphy, Greendot Design
Printed and bound in China by 1010 Printing

I am not a cat man, but a dog man,
and all felines can tell this at a glance—
a sharp, vindictive glance.

JAMES THURBER

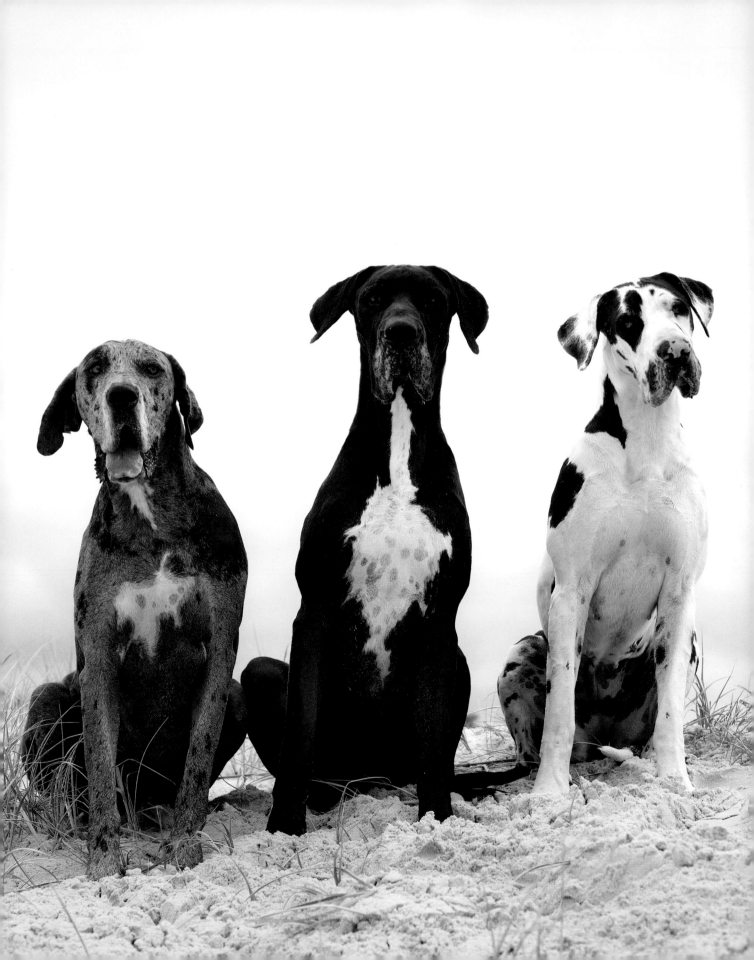

contents

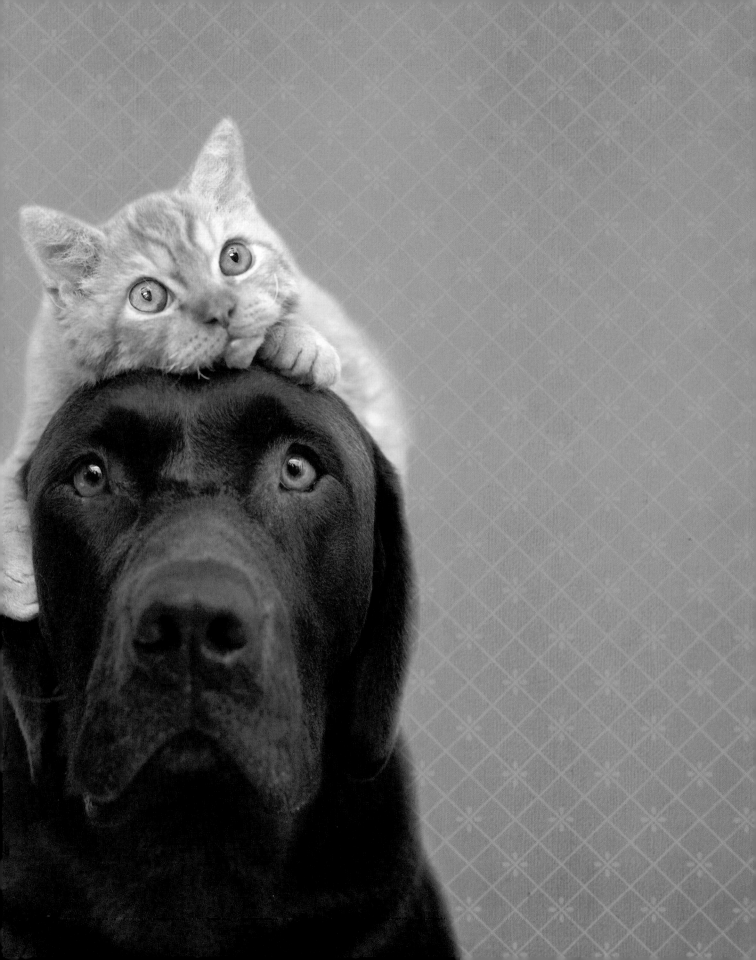

Overture

ALAS. WE LIVE IN THE AGE OF CATS.

I suggest you sit down and, if you've not already done so, cover your dog's ears. Better yet, send him out of the room. The shock of what I must tell you may not be fatal, but it will certainly upset his internal plumbing to the degree that inner peace and sweet regularity will become but a happy memory.

There are now two hundred million more domestic cats in the world than there are dogs—twenty million more just in the USA, thirty million more in China, with several other nations close behind.

Even in the few countries like Australia where dogs are in front by a nose or where pet cat numbers are falling, the feral cat population is climbing faster than a singed gibbon. The global number of stray and feral cats is now so impossibly large that it cannot even be guessed at—calculating π to one trillion decimal places has become a pitifully easy task by comparison, and only serious geeks with utterly crippled social skills need apply.[1]

Cats are breeding machines, much like rabbits, mice, and Marlon Brando. In the time it takes you to read this page, thousands more kittens will be born. In just a few years, a single pair of cats and their subsequent offspring can serve up more than half a million sofa-scratchers. Even the most tenuous grasp of mathematics reveals that if sanity is not restored, cats will soon outnumber the soiled grains of sand they scatter imperiously from their pungent litter boxes. In short: It's a deluge, and it's only raining cats.

The cats' unchecked hyperfertility that rivals the spread of a computer virus or a mutant strain of bathroom mold is clearly of great concern. Nevertheless, the weightiest responsibility sits awkwardly upon the narrow shoulders of cat owners themselves—a curious and fickle clutch who, though not necessarily archetypal losers per se, are likely to be divorced, widowed, or separated, according to a recent British survey.[2] Many own two, three, four, or more cats, and the legend of the mad cat lady, a fractured, sickly, embittered recluse whose domicile is decorated with fur balls and perfumed with herring vapors, really does have a basis in fact.[3]

CATS ARE FILLING EVERY CREVICE OF HUMANITY LIKE EXPLODING POPCORN.[4]

Meanwhile, lonely and irrational cat fanciers shovel kittens into their emotional bunkers with frenzied enthusiasm, and thus the popcorn growth cycle feeds upon itself until, gorged beyond restraint, the population approaches critical mass.[5] One dark day we will wake to find a suffocating blanket of cats has covered the entire globe like a mewling funereal shroud.[6]

At the risk of inciting a Cat Fancier Jihad,[7] I contend that the rise of the cat and the collapse of human civilization are inexorably linked. Consider, if you will, that in the United Kingdom cat numbers have doubled in just the last thirty years.[8] During those three decades of exponential cat ownership, a period referred to as the fish-breath bubble,[9] the world has changed a great deal. Some would say for the better. I demur.

Since 1980, new communication technologies have made it possible for people to make contact without ever connecting in any meaningful way. Fantasy video games have replaced childhood adventure, and public libraries have been usurped by random, semiliterate online search engines. The result: Divorce rates are through the roof, vandalism is rife, hate crimes are increasing, global conflict is at an all-time high, and don't even get me started about reality television.

Ours is an increasingly impersonal and indulgent world where ephemeral pleasures are more keenly sought than anything tangible and enduring.[10] As a species, we no longer care very much about anyone or anything but ourselves. Our vital genetic urge for discovery and social interaction lies splayed and immobile in a giant beanbag of complacency. Automatic doors, spell-checkers, microwave ovens, virtual reality, and free home delivery—every innovation a love-handled advocate for life lived in the seated position.

ENTER THE CAT.

CATS THRIVE IN THE CURRENT CLIMATE OF PASSIVE NARCISSISM.

Unlike dogs, they require little effort and virtually no emotional investment in order to flourish. Falling neatly into a domestic subclass containing hamsters, sea monkeys, and sock puppets, cats are the type of pet you have when you don't have the time, energy, or space for a pet. Like Hollywood socialites, they seem to have no obvious needs beyond being noticed and can apparently survive indefinitely on air kisses and the occasional seafood canapé. Caring for a dog, on the other hand, requires a great deal more effort. It's not nearly as challenging as raising a child, but it's a whole lot harder than making pizza from scratch. The rewards are far greater, but so is the mess.

The sheer volume of cats has given cat breeders and procat bloggers[11] all the justification they believe necessary to declare cats the world's most popular pet.[12] But popularity, as Britney Spears will attest, is no hallmark of quality or even true affection. If modern history has one central tenet, it is that the masses will embrace anything if it's cheap and easy. This is our fundamental weakness and will almost certainly lure the entire human race to its doom. Thermonuclear Armageddon would require far too much cerebral effort—our collective fate is a bear trap baited with a cheeseburger.

We evolve by overcoming hardship, celebrating dynamic social diversity, asking questions, and enjoying challenges; we devolve by succumbing to convenience, selfishness, ignorance, and sloth. The growing number of cats and cat owners is, therefore, symptomatic of societal decay, the demise of virtue, and wholesale rejection of the real.

Within the core of this crisis lurks the most putrid lie that ever crawled off a human tongue: that cats are equal to or better than dogs. The audacity of this statement leaves one unzipped with incredulity. In our hearts, we all know it to be criminally false but, given that the guilty outnumber the innocent, demolishing the ridiculous cat supremacist conspiracy seems hopeless.

Smug ailurophiles[13] never get tired of telling us that cats were once worshipped as gods.[14] Never mind that primitive cultures were also known to worship lizards, rats, and dung beetles,[15] the question that leaps to mind is where, exactly, are these great cat-worshipping cultures now?[16]

The fact is that by the time the first wave of starving wild cats followed a plague of mice into the granaries of Egypt, dogs had been a part of the family for thousands of years. Indeed, well before mummified cats[17] were stacked up in pet cemeteries like so much dried fish, pet dogs were being buried beside their devoted owners.[18]

There's not much more to say about this. Bizarre religions and pet fads come and go, but dogs keep on working and playing with grateful families just as they have since 13,000 BC. Sure, cats were once worshipped by a kooky, eyebrow-shaving sect—but dogs continue to be loved by everyone else.

Despite the perverted trend toward cat domination, the numbers don't quite add up. There exists a profound universal bias toward dogs that has been consistently documented in literature throughout the ages and, more recently, in television and film. Dogs consistently win the part of square-jawed hero and empathetic ear, while cats compete vigorously with British character actors for the role of effete villain, whining sidekick, and insufferable snob. Is this grossly unfair? I think not. By deed and association, cats have won a most unenviable reputation due to their predilection for uncivil disobedience and conditional affection.

In contrast, beloved, noble, and heroic dogs abound in fiction and folklore simply because they are legion in life.

There are countless verified tales of canine loyalty and bravery from dogs large and small who have sacrificed themselves for those they love. They have guarded our families and homes at great cost, fallen beside us in the trenches, and, while standing firm, bared their teeth against evil intent irrespective of its terrifying form. They have even saved us from ourselves.

When bullets shred the breath of angels and bombs shake the foundations of our faith, dogs rally to our aid without question, while cats pause only to steal food as they scurry to a warm, soundproof nook and resume grooming their nether regions. Consider the many children, men, and women saved by search and rescue dogs in the London Blitz during the darkest days of World War II. And again, when our hopes for the new century unraveled in the face of hideous terrorist atrocities, dogs stood tall.

As the twin towers of the World Trade Center shivered and twisted sickly from the hideous explosions, the crowded fire stairs soon filled with screams and smoke. In the midst of this choking madness, two guide dogs calmly led their blind owners down the endless spiral of stairs to safety. Then, during the horrific aftermath, some three hundred search-and-rescue dogs were rushed to Ground Zero to help emergency teams carry out the hazardous rescue and recovery mission. They went where no man could. The excruciating heat, toxic dust, and collapsing rubble was so perilous that several dogs died in the line of duty, and many more were injured. Eighteen families remain whole today because of their heroic efforts. No one was saved by a cat.

Dogs aren't the only ones shortchanged by fraudulent feline favoritism. Kittens are as cute as anything that ever fell into a bowl of milk and blew bubbles out its nose before vomiting into a sneaker.

However, as companion animals, cats are ultimately disappointing—much like a cheap haircut that makes you look younger, but only from the back. You wanted a pet, but what you got was a plush toy with an attitude problem.

The current cat surplus doesn't bode well for *Felis catus*, and a violent market correction is inevitable. It won't be pretty. Sadly, having already made one poor choice, disgruntled cat owners often go on to make another that is far crueler—disowning and dumping their pet.

In the USA last year, some ten million lost and forgotten cats and dogs ended up in rescue shelters. The records tell us that stray cats are fifteen times less likely to be claimed from the shelters by their owners than dogs and are also at least 30 percent less likely to be adopted by new owners. As a result, cats made up most of the five million abandoned pets who never found another loving home and thus, after a short and terrifying period of confusion, were euthanized via lethal injection. There is no truer measure of our relationship with cats and dogs than this heartbreaking statistic.

I must stress that I am prodog, not anticat. The principal purpose of this book is not to criticize cats or their owners,[19] but to champion the many exceptional virtues unique to dogs. I applaud the qualities of cats, both of them, and acknowledge the inherent danger of gross generalizations. There certainly are some magnificent cats and a few remarkable cat owners as well—I happen to know two or three myself.[20] Words spoken against equality catch in the craw of any decent human being but, while all living creatures may bask in God's benevolent and undivided gaze, any suggestion of pet parity goes against science and nature both.

For self-serving reasons, both commercial and psychological in nature, the emotionally dislocated cat lobby has alternately bullied, misled, and guilted us all into accepting the bewildering cat-dog similarity falsehood. So often have cats and dogs been shoehorned into the same sentence that the perverted propaganda has become demented doctrine. We now ask our children if they would like a dog or a cat, when lumping dogs with cats is as arbitrary and surreal as pairing polar bears with flamingos, a butterfly with a ham sandwich, or Frank Sinatra with New Kids on the Block.[21]

There may be compelling if unsettling reasons why people might want a cat, but although I can respect their choice, I cannot accept the idea that there is any other pet that compares to a dog. Not a one.

As surely as sports journalism is a halfway house for the criminally insane, our world is overdue for a wake-up call. We must halt society's cat-induced decline while we still can. Haute cuisine has already been reduced to a Pop-Tart on our watch. It won't be long before someone invents gum that chews itself and pants you don't have to take off when you use the bathroom. We must recharge our idle bones with hot sap and rise up, lest the ancient races of dogs and men are reduced to anonymous notches on the ammonia-scented scratching post of history. It's time to stand up and fight for Fido.

The battle of which I speak is not against cats or cat lovers. The honey-soaked irony is that the restoration of dogs to their proper place, the righting of modern civilization, and the salvation of cats are all one and the same thing. By claiming cats are equal to dogs as pets, the bar has been raised so impossibly high that felines can only fail, and in failing suffer greatly. I'm not saying cats can't play an important and charismatic role in the civilized world at some future date. Bear in mind that dogs have been around for a great deal longer than cats. It follows then that, given enough time and opportunity, cats may one day become almost as bright and engaging as dogs are today.[22]

There is a genuine humanitarian need to help dogs retake the pet podium, cats regain their comfortable niche in the world, and both to retrieve their long-lost dignity. Balance should be restored by knowledge and compassion, not the volume of cat corpses an underfunded animal shelter can incinerate in a calendar year. Such a mission of animal welfare is of vital importance and urgency. Were any other species subjected to such barbaric culling based purely on laziness and callous whimsy, the more zealous action groups would be pulling out their dreadlocks. It's time to reprioritize our global conservation agenda—we cannot wait until we have developed Viagra for pandas and initiated a national Botox program for turkeys. I'm all for saving whales and protecting the great apes, but I've never buried a minke in the backyard and no gorilla ever brought me my slippers. We are talking about family members here.

The facts have been obfuscated by clouds of cat hair for far too long. Mercenary pet peddlers and shortsighted cat-aholics must be slapped across the jowls with the frozen halibut of justice.

Cats shall hence be freed from the burden of unreasonable expectation and dogs shall no longer be denied proper acknowledgment of their supreme devotion, intelligence, compassion, courage, infectious optimism, and all-round furry greatness.

Allow me to spell out a divine truth as enduring as any prehistoric stone monolith burnt by the sun for fifteen millennia:

dogs.
are.
better.
than.
cats.

And now, if you'll just turn the page, I'll happily tell you why.}}}

There is a dog for

For every breed of cat in the world, there are more than thirty different breeds of dog.[23]

In fact, almost as many dog breeds have become extinct as cat breeds have ever existed.

everybody

Dogs come in all shapes, sizes, colors, and most important, dispositions—from gentle giants to little dogs with big personalities. This canine cornucopia means that the perfect dog is out there to complement every single human being's personality and lifestyle. Regardless of where you live, no matter how noble your endeavors or twisted and shameful your secret quirks, there is a dog that is just right for you. I guarantee it.

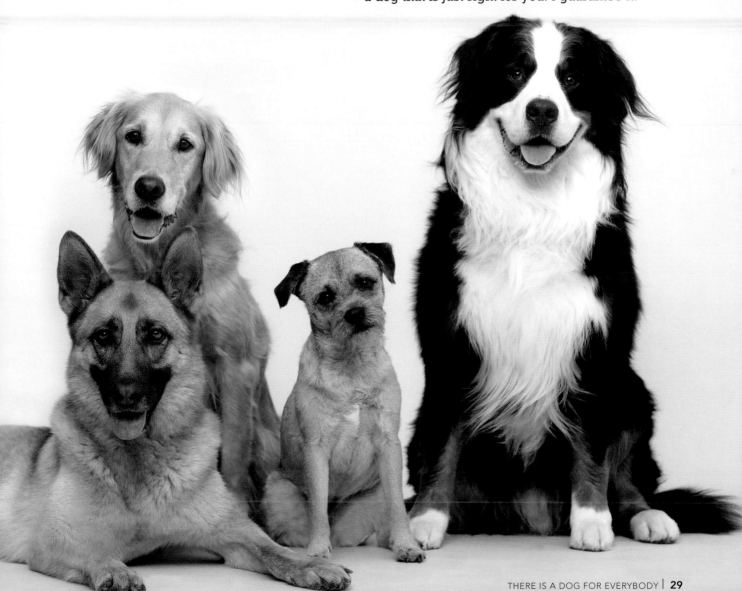

THEY ARE INTREPID ADVENTURERS.

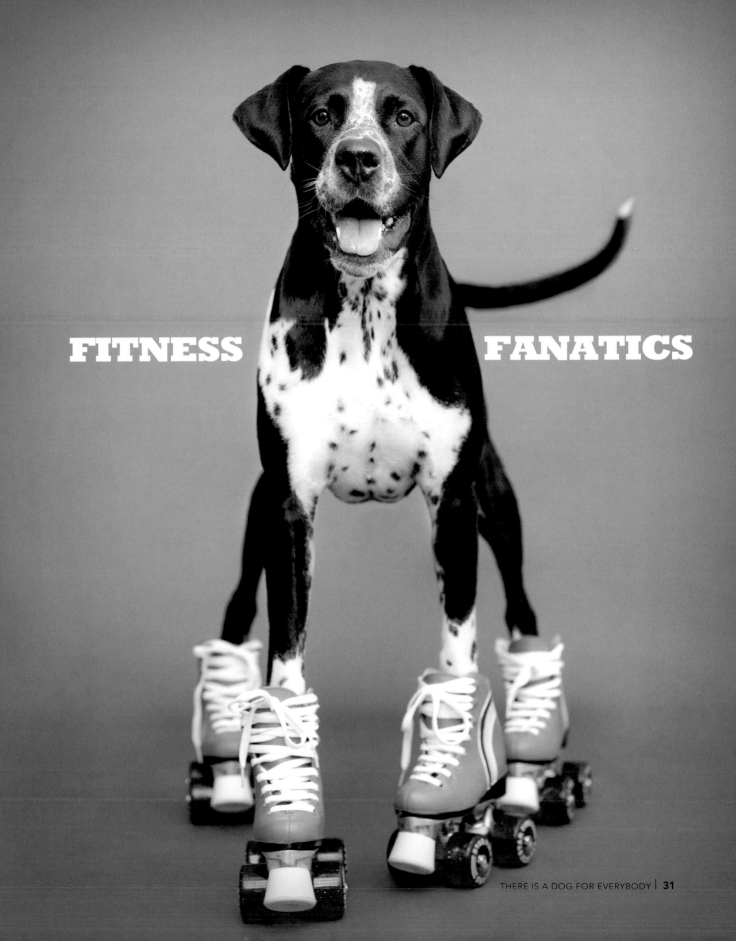

FITNESS FANATICS

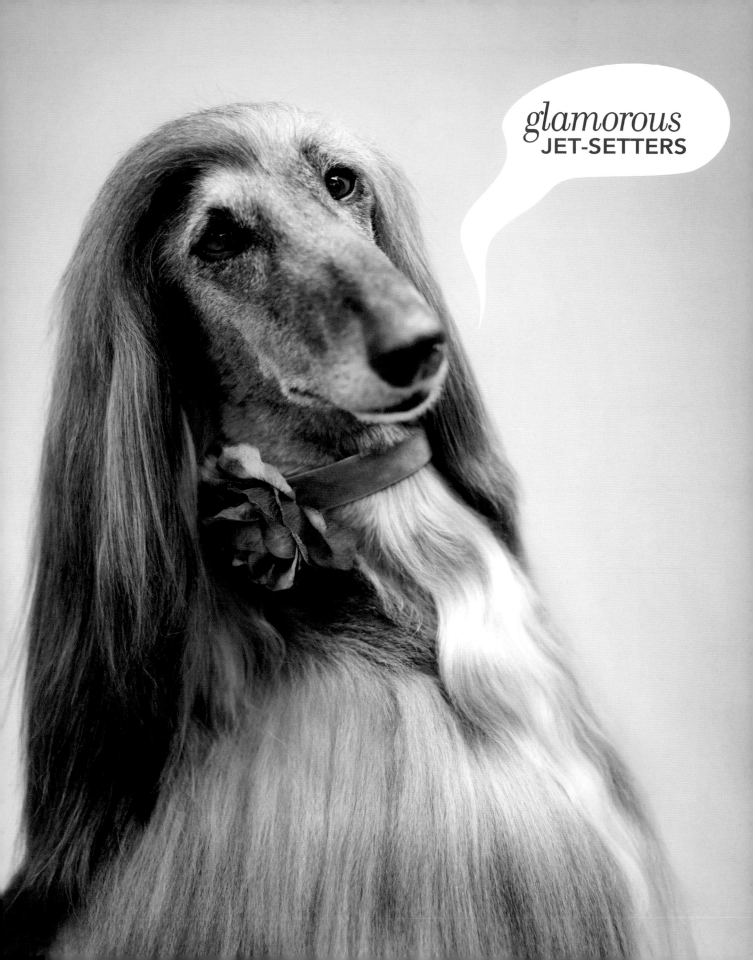

NO-NONSENSE
**TOUGH
GUYS**

charismatic
COUCH POTATOES

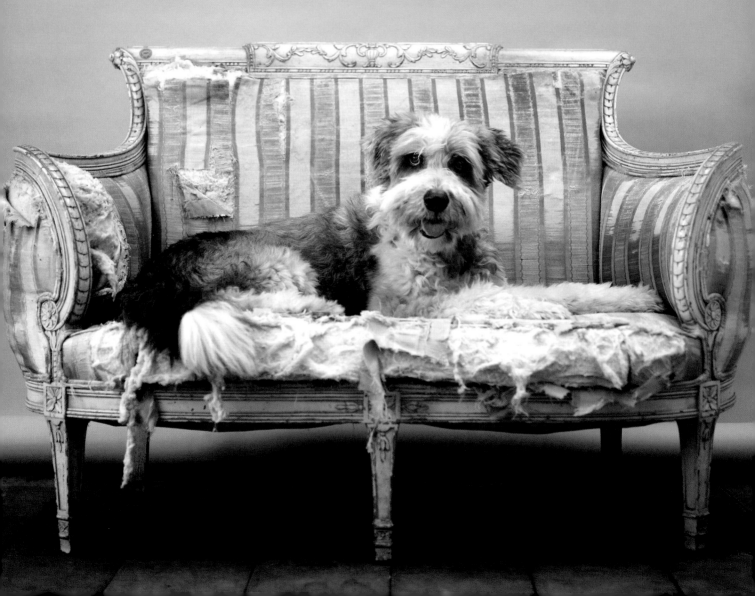

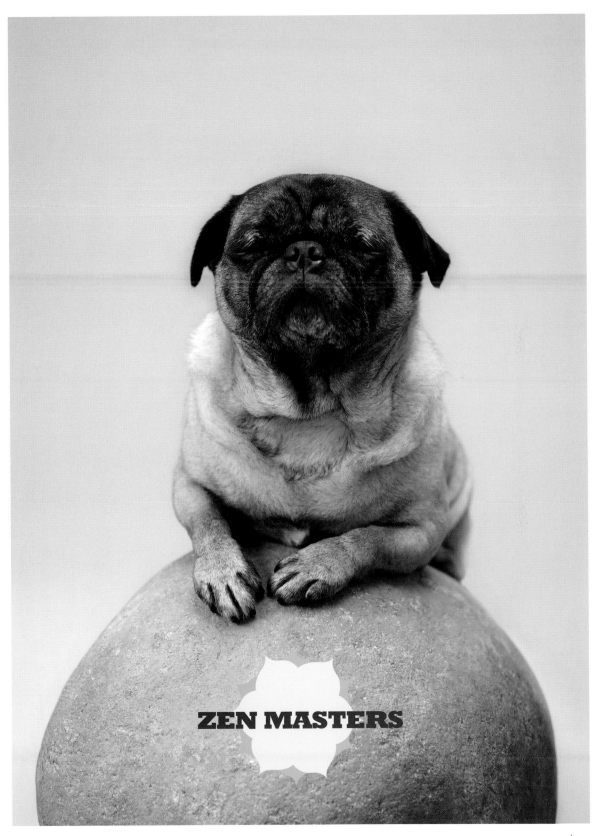

ZEN MASTERS

PARTY
ANIMALS

TIMID LITTLE
wallflowers

And, embarrassingly
enough, even dogs who
think they are cats.[24]

Cats, however, all fit pretty neatly into the same silhouette and share the same whiskered antipathy for the noncat world.

Only superficial differences and varying degrees of neurosis distinguish one breed from the other.[25]

THE LESSON HERE IS **THAT DOGS MATCH UP TO PEOPLE,** BUT PEOPLE MUST MATCH UP TO CATS.

Cat lovers believe that makes them special. And if the definition of *special* extends to bizarre subgroups who champion inexplicable passions such as nose flute music, tobacco spittoons, Ed Wood movies, and lederhosen, then I suppose they are right.

I'd ask you to consider what warped and stunted contrarians would turn their backs on man's best friend and identify themselves as cat people. However, we have only so much space to dwell on the failings of feline fanciers.

Instead, I'd like to highlight what an extraordinary achievement it is for dogs to be universally acknowledged as man's best friend at all.

Dogs are man's best friend

The competition for the title "man's best friend" was not merely a showdown with cats. In fact, cats didn't figure in the contest any more prominently than, say, quail.

Dogs won this affectionate accolade against and above all other species on planet earth, from aardvarks to zebu.[26]

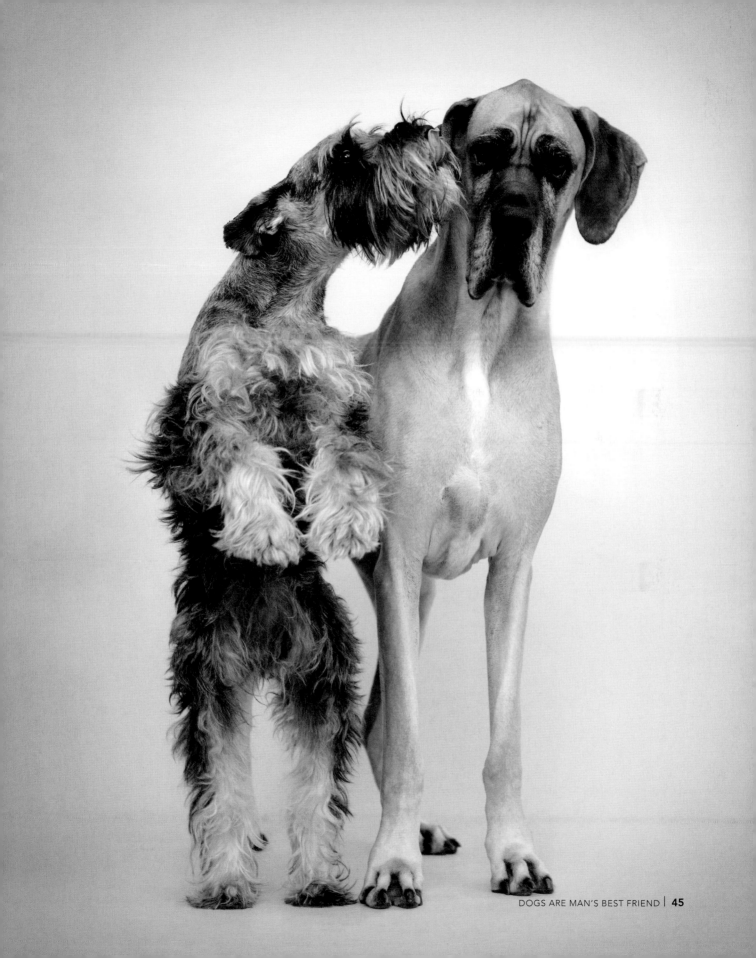

The selection and elimination process for man's best friend took place over thousands of years. Every creature has had plenty of chances to stand up, or not, as in the case of snakes and flatworms. The physical parameters of the human condition quickly narrowed the field. By virtue of disparate scale, insects, hummingbirds, elephants, whales, and giant squid washed out early.

Jellyfish, like the silicone implants they resemble, turned out to be inherently false. Most intimate encounters were thus awkward and regrettable.

Marine creatures in general did not float to the top in a good way,

with the exception of dolphins, who came very, very close to making the final cut because of their extraordinary intelligence. But in the end, their incessant, high-pitched chatter really got on everybody's nerves.

Amphibians and reptiles had a similarly poor showing due to their inherent slithery clamminess.

Giant tortoises alone won an honorable mention in spite of their leathery necks and bony protuberances, primarily because their gentle and deliberate manner was so endearing.

But even casual lunch dates took forever and the urge to complete their every sentence for them proved impossible to resist. It was never going to work out.

Lemmings, though undeniably cute, had a tendency to lead their owners to an untimely demise. Similarly, apex predators like tigers, lions, and Kodiak bears were put to one side because they couldn't be trusted to babysit in an emergency.

Domestic ungulates such as cattle and sheep are pleasant enough in a docile, plodding kind of way, but on the whole, they are not very engaging and tend to go with the flow to an infuriating degree. Pigs, however, are very bright and share our unbuttoned enthusiasm for comfort foods and long weekends; they really should have gone a lot higher in the draft. Their ranking suffered terribly due to the fact that most people openly abhor mud and secretly harbor an inordinate fondness for bacon.[27]

Monkeys and great apes, with whom we share so many similarities, were obvious contenders. They certainly were impressive.

In general, however, their eyes were too close together to be considered completely trustworthy. Plus, while it's nice to be nostalgic about your common history, a positive and balanced relationship needs to evolve. No one wants to be held back by a friend mired in the past.

Friendships of any depth were impossible to establish with rhinos, armadillos, pangolins, porcupines, echidnas, tenrecs, and hedgehogs, since their defensive barriers proved insurmountable.

When stating their case, parrots said only what they thought we wanted to hear, while moose simply bellowed out their own name again and again—it got old pretty quickly. Platypuses were simply too weird and thus impossible to introduce at parties. Chameleons are not nearly as adaptable as everyone says. Obsessive jogger types are never popular regardless of species, which scratched horses, antelope, roadrunners, and cheetahs from the starting list. And beavers, well, what can I say? No one wants to live with a workaholic.

In terms of compatibility, it was surprising how few animals could interact with human beings with any comfort: If you think it's hard to prepare interesting meals for someone on the Atkins Diet™, try living with a panda. No one has yet invented a thermostat that can make life comfortable with a penguin or a harp seal. The same scenario, in reverse, was true for fennec foxes and giant tube worms. Blanket battles are a certainty.

Communication and general social skills were the most profound problems.

When there are no clear ground rules, it's almost impossible not to offend. For example, shaking hands with a Maine lobster or a Tasmanian giant crab is asking for trouble. Roses and goats don't mix. Ostriches and emus can't stop themselves from constantly peering over your shoulder, which, if unchecked, is certain to create serious paranoia. There is no right way to look at a spitting cobra. How do you explain the saltshaker on the table to a visiting slug? If a bear says he wants to sleep in, then you have to tiptoe around the house for months. Songbirds don't know what a hangover means. Similarly, howler monkeys do not have an inside voice.

Try as we might, most animals simply are not destined to connect with humans in a meaningful way.

Just so you know, cats were gonged off the stage in the preliminary rounds due to lack of interest (on their part).

On the basis of looks alone, however, they still outlasted several other nocturnal hunters such as camel spiders, bats, and owls (though this came down to a coin toss). The principal reason given was that the clash of schedules left everyone exhausted, but the truth is that humans don't like to be watched while they are sleeping.

In the end, it wasn't even close; dogs first, daylight second.

FYI: a snapshot of the bracket results for the final "sweet sixteen" contenders looks something like this: }}}

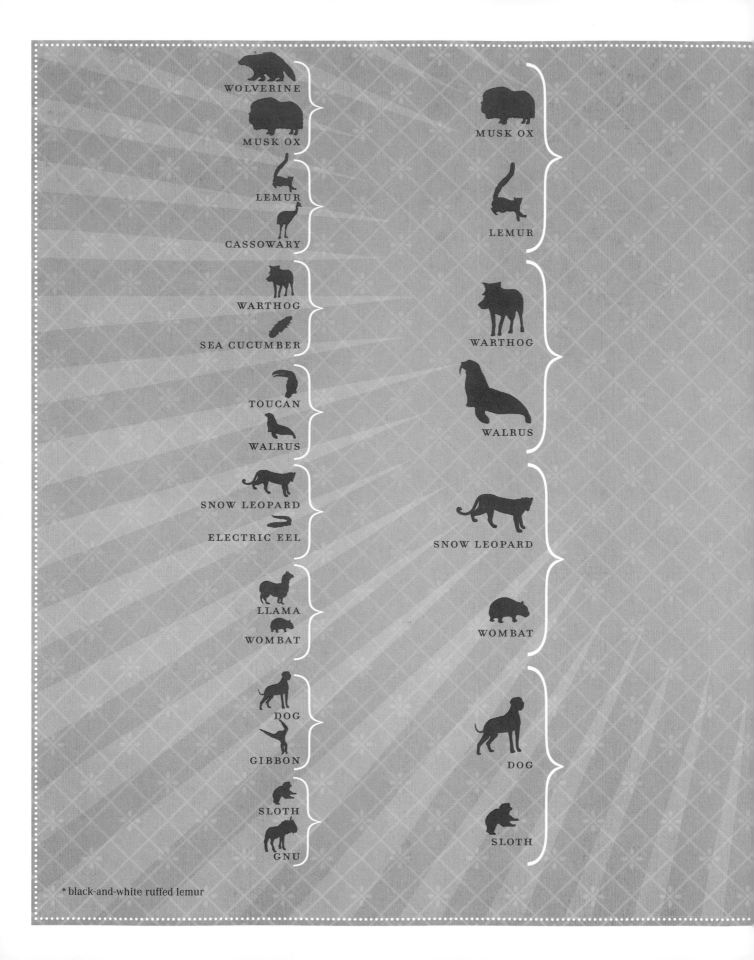

WOLVERINE

MUSK OX

MUSK OX

LEMUR

LEMUR

CASSOWARY

WARTHOG

WARTHOG

SEA CUCUMBER

TOUCAN

WALRUS

WALRUS

SNOW LEOPARD

ELECTRIC EEL

SNOW LEOPARD

LLAMA

WOMBAT

WOMBAT

DOG

GIBBON

DOG

SLOTH

SLOTH

GNU

* black-and-white ruffed lemur

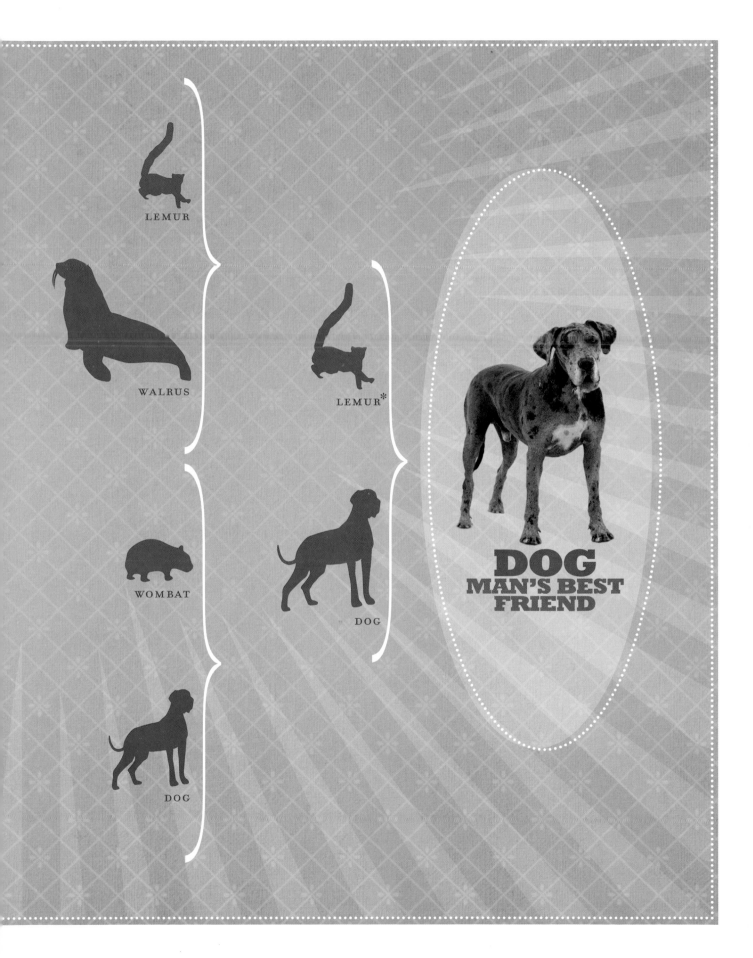

LEMUR

WALRUS

WOMBAT

DOG

LEMUR*

DOG

DOG
MAN'S BEST
FRIEND

The reason dogs surpass all other species is quite simple: They get people–they really do. It's been this way since dogs and humans first bumped into one another and thought, "Hey, this could work!"

For more than fifteen thousand years, dogs and human beings have been drawn together by mutual cooperation, shared values, and a sense of joyous fraternity.

Cats, on the other hand, came for the mice and stayed for the fish sticks. It goes beyond the fact that dogs are motivated by love and cats are motivated by food.

In simplest terms . . .

Dogs are social cats are sociopaths

One need only look at the open, friendly face of any dog to find evidence of their affable nature; dogs are fundamentally social creatures. They see the bigger picture. They appreciate togetherness. They care about others.

Dogs want to make friends. They want to see the best in everyone, and they want to learn as much as they can about whomever they meet. Admittedly, inhaling each other's posterior is not the most appealing way to gather such intimate information, but neither is cyber-stalking on Google. Furthermore, if human greetings can range from high fives, hugs, and handshakes to air kisses, backslaps, and rubbing noses, then who are we to draw the line at a curious sniff?

The concept of family is vitally important to a dog. A dog will live anywhere and endure anything if it means the whole family is safe, happy, and stays together.

Cats, on the other hand,
focus on comfort.
Sure, they can be social enough
when it suits them,

though when that will be is generally hard to say.

To dogs, you are the great love of their lives.

TO CATS, YOU ARE THE COURTESAN OF THE MOMENT.

**DOGS SEE YOU
AS A PARENT,
PARTNER,
BEST FRIEND,
AND SOUL MATE.**

Cats see you
as a source
of warmth
and food.

If you care for dogs long enough, they become members of the family.

CATS
BECOME
DESTRUCTIVE
HOUSEMATES
WITH
BAD BREATH.

While cats have a keen sense of their own needs, dogs have a remarkable understanding of ours.

Their devotion is pure and sincere. We are foremost in their minds in every exchange. Dogs carefully gauge our feelings, and what they learn is then immediately reflected in their behavior.

A subtle frown instantly tells a dog she made a mistake.

A KIND WORD
LETS HER KNOW
SHE'S BEEN GOOD.

BETTER
THAN GOOD!

In 2002, scientists from Harvard University proved that dogs are actually more adept at intuiting human emotion, or "reading" people, than our closest living relatives (by which I mean chimpanzees, not your in-laws—although this may also be true in many cases).

This is what sets dogs apart from all other animals and especially cats: Dogs genuinely have a sense of what we are trying to communicate. And with a little patience, we can also understand most of their feelings and intentions, too.

If you talk to dogs, they listen.

You can talk about nothing for hours on end, and they will keep on listening to you, ears cocked, eyes focused, desperate to get the gist of what you are trying to tell them. Moving only to offer gentle encouragement by laying a tender muzzle in your lap or acknowledging you with a slow, supportive wag of the tail, your canine kin is the epitome of rapt attention, measuring every syllable with the intense concentration of someone straining to make out the precious final words of a dying friend who, for some inexplicable reason, has a mouthful of marbles.

To cats, virtually everything you say is background noise, including their names. They may turn to observe you dispassionately for a moment but, having established that no tuna tidbits are forthcoming, they will tune out quicker than a twitch of the tail. You could cry for help from beneath a flipped tractor, wring every last drop of poetic anguish from a broken heart, pour out all your hopes and dreams in a torrent of emotion—to a cat, it would mean far, far less than the sound of a can opener.

Cats don't know what we want, and they don't care. Although chronic cat fanciers choose to interpret this ignorant ambivalence as superior aloofness, the truth is far less flattering.

If you ever see a cat in a state of repose and wonder what is going on inside its head, the answer is almost always, not a lot.[28]

As gifted as they are at hunting, hiding, and licking their private parts, cats simply don't have the mental or emotional capacity to consider the feelings or interests of other creatures.

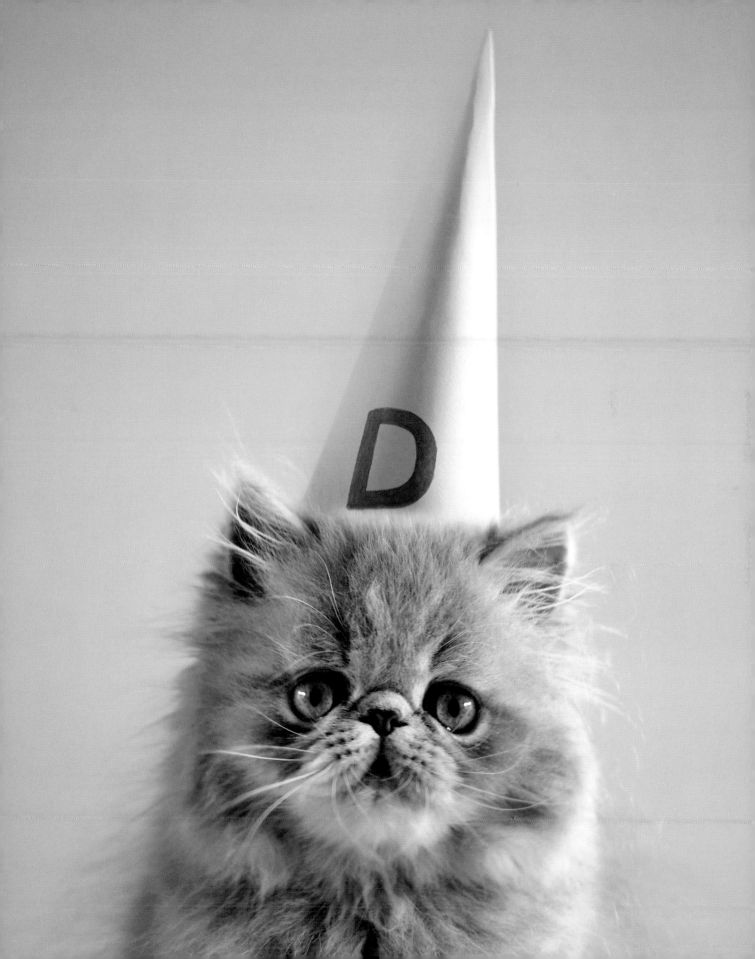

For better or worse, and in every way that matters, cats and dogs are nothing alike. Feline fabulists try to claim some shared qualities of note, but this is simply not so.

FOR THE RECORD:
DOGS ARE
INHERENTLY
GOOD.

CATS ARE
SOMETHING
ELSE
ENTIRELY.

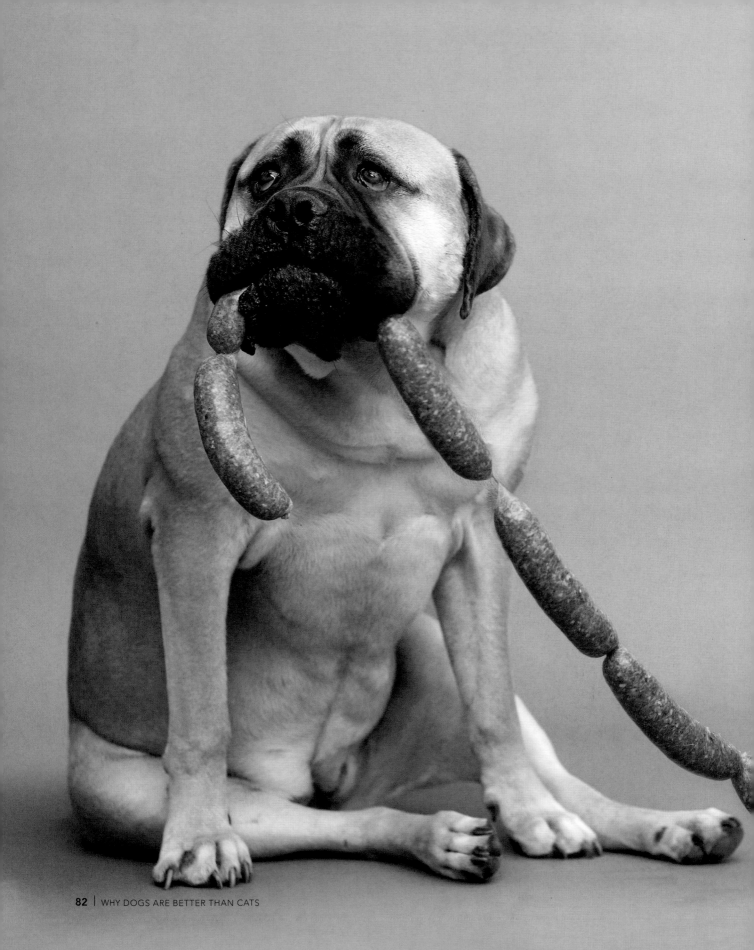

Dogs can appreciate both the nature of their actions and the subsequent consequences.

The canine code of conduct is based on mutual respect and underscores a higher sense of justice.

In contrast, cats do not recognize the authority of any court we choose to convene.

The perfect way to showcase just how different dogs and cats really are is to highlight their respective gifts for learning. Dogs can be taught, by example and intuition, just about any task you can imagine.

Contrary to popular belief, you can teach an old dog lots of new tricks.

But you can't teach a cat anything, regardless of age.

This fact is so well established that successful puppy schools and dog-training academies have sprung up all over the world—much like our own centers of higher learning. Like us, dogs absorb lessons quickly, either by being rewarded for the desirable result or punished for the undesirable outcome. And just like us, the reward system seems to work a whole lot better for all concerned.

While dogs are born with full hearts and open minds, cats arrive with certain "cat software" preinstalled. Upgrades are expensive, infrequent, and deliver only marginal improvement.

Since cats are largely self-taught, humans play little or no part in their education process. Indeed, our most virtuous example is meaningless to cats. Rewards or punishments are seen by them as random acts, entirely unrelated to their own behavior. To a cat, a human is less a teacher, mentor, or role model than a dysfunctional vending machine. Cats are hardwired to know that meowing loudly makes the food come out. Sometimes they have to swat the machine a few times to get it to work properly—they blame the technology.

The phrase "familiarity breeds contempt" has its origins in the description of cat-human relations. Cats will never adore their owners or aspire to assimilate in the way a dog does. Over the course of their lives, cats do not venture down any path toward devotion but merely attain what can be described as conditioned tolerance. The more a cat realizes its owner is not a threat, the less anxious it will become, and the more amenable it will be to allowing the owner to encroach upon its personal space.[29]

But at no point, outside of dinnertime, do cats interpret the actions of their owners as anything but peculiar and pointless. They may be wary of our size, speed, and strength, but they do not grant us any further credit. They can discern no method in our madness. Our most fervent attempts to communicate our intentions and demonstrate our wishes wash over them like a midnight infomercial for mustache wax. Just as the ignorant person believes the world is full of fools, cats suffer through what they see as our incomprehensible stupidity.

It is highly unlikely that, even given a lifetime of intensive training, a cat can be taught to do anything useful.[30] For what it's worth, however, if the world's fate ever hangs in the balance after being overrun by shoals of imperialist goldfish, cats will enjoy their finest hour.

People train dogs.
Cats train their owners.

In other words, cats don't ever learn anything other than how to get your attention. It's up to the owners to modify their environment and routine so that it pleases the cat—or causes least offense. Sure, they can choose to do things their own way and damn the consequences—but at some stage they have to sleep, eat, use the bathroom, and go to work, while their cat has nothing to do but plot sweet revenge.

They say there are no bad dogs, only bad owners. That may not always be true, but with patience and kindness

even the worst dog can be taught how to behave.

A bad cat is pretty much
a lost cause and needs
to be committed.

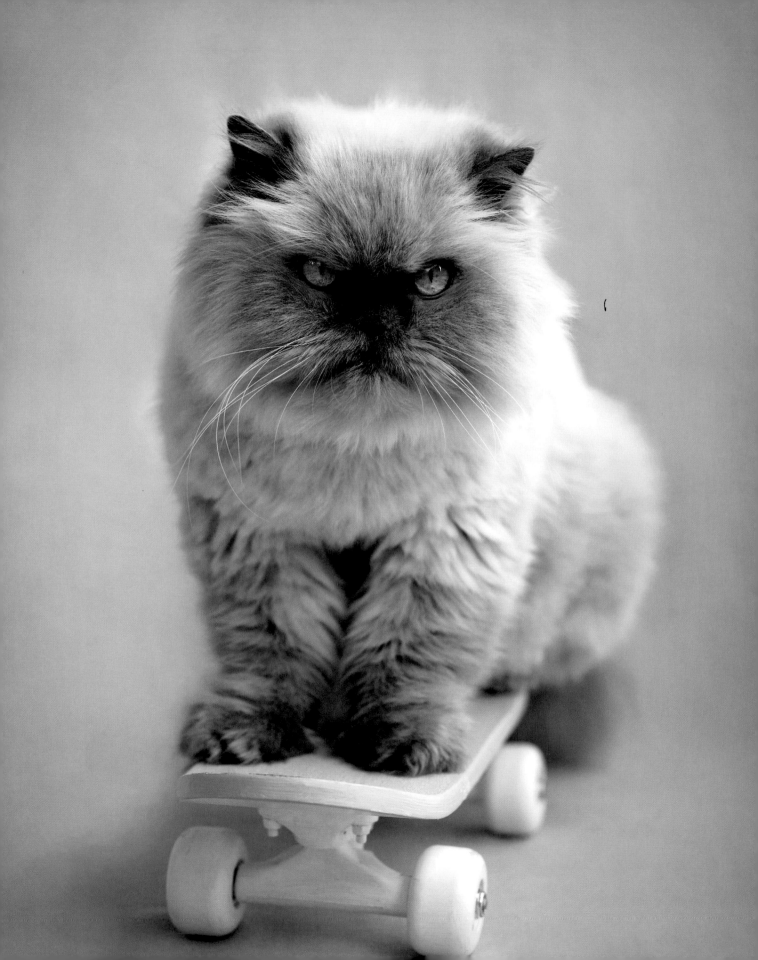

It is completely normal for any dog to be part of a team effort, embracing all the give-and-take that such a complex dynamic requires.

However, after a cat is weaned, it is wholly unnatural for it to support, depend on, or wait on anyone.

Behavioral scientists believe that keeping a cat as a pet means forcing it to remain in a kittenlike state for life. In effect, it becomes a "catten," a maladjusted creature that is neither cat nor kitten.

Like thirty-year-old men who still live with their parents, house cats are mired in a sort of delinquent adolescent state that is ill at ease in polite society and not too kind on the soft furnishings, either.[31]

Cats are not inherently stupid or inferior.

Despite the fact that they exist in a vague and unresponsive state that is neither awake nor asleep, they have self-awareness, problem-solving abilities, and a pretty sharp memory, and enjoy a wide range of truly remarkable talents. It's just that dogs are, quite simply, far more intelligent and alert to the world at large. Thus, dogs are on a whole other level when it comes to establishing a complex, enduring connection with human beings and each other.

Dogs, like other truly sentient beings, have a full range of emotions. Whether it's the ups or the downs, they feel exactly what you feel, albeit to different degrees.[32]

CALM
and contentment

UNDERSTANDING
and compassion

Melancholy,
disappointment, betrayal,

and loneliness

Hope

and anticipation

JEALOUSY AND

desire

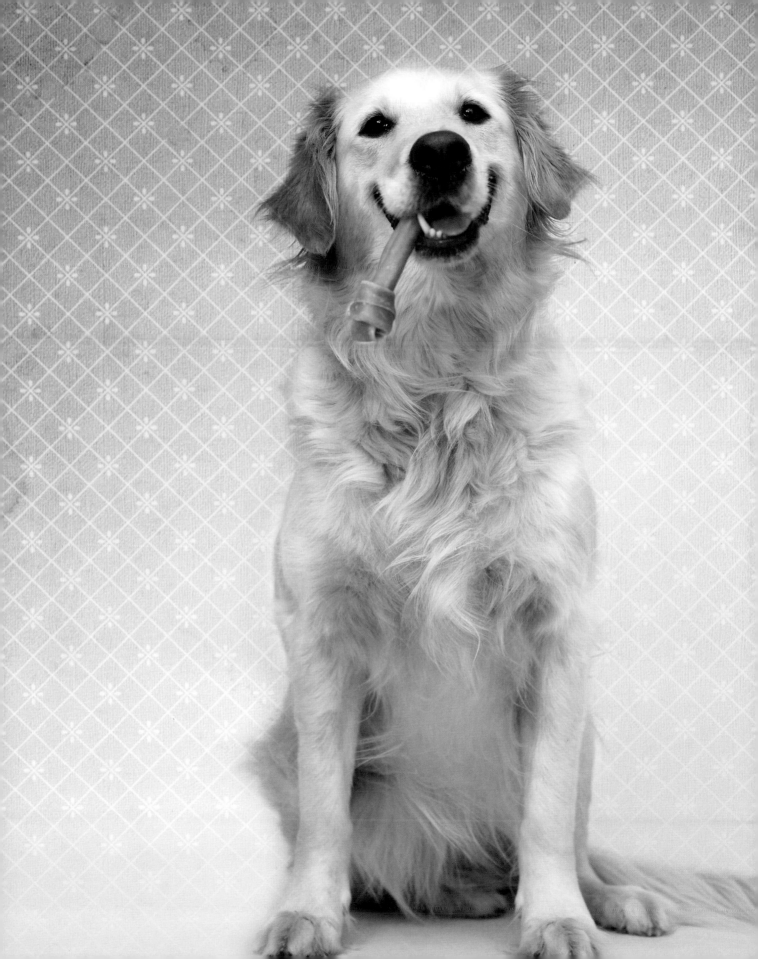

Happiness,
gratitude,
wild delight,
and euphoria

Even depression

In contrast, the cat is Narcissus with whiskers and doesn't have deep pockets when it comes to sensitivity and empathy.

Cats experience pleasure and feel pain, without any doubt, but their capacity for true engagement is limited by an emotional hard drive that is more windup toy than supercomputer. Physical hunger, potential prey, and possible threats or the absence thereof are what largely determine if and when a cat's moods and feelings stray from contented apathy.[33]

They are either

TERRIFIED,

or they feel compelled to hunt for love or food.

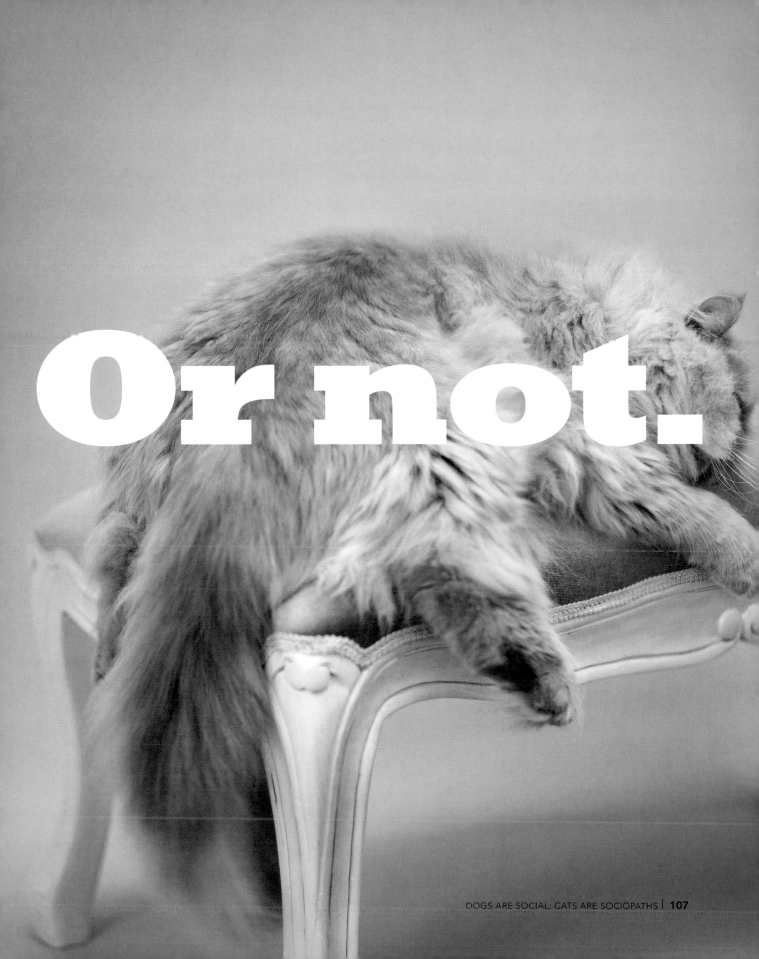

Or not.

To dogs, you are the leader of the pack, their savior and guiding light. You are the beautiful, warm, nurturing star around which their world revolves, the emotional center of their universe.

While you are away at work, your dog is impatiently waiting for you to return. By the time your toes touch the welcome mat, your dog is exploding with joy. She's glad you're back, and boy, does she show it.

Very few cats will even surface to acknowledge, let alone celebrate, their owner's arrival, unless of course they are hungry. When you finally stumble across their path, they look up, bemused, as if to say:

"What, are we out of salmon kibble already?"[34]

To cats, a human being is basically a vertical speed bump, a fabric-wrapped monolith, or a fleshy tree simulator.

At best, you are a moderately amusing prop.

A curious lumbering entity that refills the sustenance reservoir.

A coincidental cohabitant of a safe lair where food is plentiful and competition nonexistent.

I am not suggesting that there is no bond between a cat and its owner; I am merely contending that the perception of this connection is far greater than the one-sided reality.

Merely calling an animal your pet does not make it so.[35]

In fact, owning a cat is akin to taking it hostage and hoping that sooner or later Stockholm syndrome will kick in. Sometimes it actually does, but you'd better keep latching all the windows and locking all the doors just in case.

Cat owners who violently
disagree for reasons of
deluded pride should try
the following experiment.
Simply serve your cat
something a little different
for dinner tonight, then
open a small ground-floor
window and keep an eye
on the clock.

See how long your cat
stays around.[36]

Cats are highly solitary animals by nature, alarmingly similar to their wild ancestors. For such antisocial creatures, one is company, and two is a crowd.[37] Sure, during the right time of year they don't mind going on a few dates. And in all fairness, they make brave and caring mothers, too.

But by and large, cats don't want friends; what they want is a canary revolution to put down.

Dogs participate with people, while cats do their own thing around people. Dogs are capable of understanding and enjoying all manner of fun and useful activities with the people they love. They can learn and adapt to an endless variety of new games,[38] all of which are motivated by the desire to understand their human playmate, affirm their affection, and feel loved and valued.

Cat play is a very different thing.

Cat games are thinly disguised training sessions for hunting and survival skills. No matter how enthusiastically cat owners wave around various toys, they are no more partners in the fun than the machine that spews high-velocity tennis balls at players trying to improve their weak backhand return.

When you watch a cat pounce on a felt mouse or chase down a ball of pink yarn, what you are observing is a perfect killer honing his craft.

Each silent, swift, sinewy movement simulates the prelude to delicious murder.

A cat loves to kill like a rabbit loves to run.[39] The bloodlust is built into their fiendish little brains. Cats are natural born Ninja assassins with a razor in every sock—pound for pound the most lethal creatures on four legs.

If a cat deposits a bloodied sparrow on your doorstep, he's not giving you a gift—he's sending you a message.

In essence, cats are borderline psychopaths.

That is why they torture mice, lizards, and birds before partially devouring their warm carcasses. That is why they try to trip you up at the top of the stairs with "affectionate ankle rubs." That is why they shed on your pillow and use your favorite cashmere sweater for bayonet practice. That is why they vomit fur balls into your Jimmy Choos.

Cat people and dog people
a study in contrasts

What makes a normal, decent human being become a "cat person"?

Obviously a trick question since normal folk would never own a cat.

But of those people who do, there are three basic personality types.

1 DIRTY DISHERS

The first clutch of cat lovers are most easily described as lazy commitment-phobics with modest romantic prospects and infrequent social obligations. Stained sweatpants and vintage rock concert T-shirts are generally the mode du jour, plus they have a disturbing penchant for novelty slippers. The primary difference between Dirty Dishers and serial killers is that serial killers get out more. If a Dirty Disher heads outdoors, it's to show a fireman where to install his ladder for a cat rescue mission. Housekeeping is not their forte; thus, their domestic environs exude an air of pungent malaise–by which I mean their homes and person have a curious and penetrating odor.[40]

Fortunately, these whiffy and vaguely spooky Dirty Dishers keep to themselves. Apart from whispering venomously at late-night television shows or plotting over a lunch of breakfast cereal against the neighbor who gave their nine-year-old a drum set for Christmas, Dirty Dishers tend to lead quiet, largely uneventful lives choked with secret regrets.

2 KIBBLE GHOSTS

Even their cats almost never see these transient lurkers, yet strangely, the food and water bowls are almost always filled, and the litter box still gets changed from time to time. Kibble Ghosts are usually highly driven people who cram all their waking energy into their professional and social lives, and thus are never around. Deep down, they know they don't have time to look after a pet or even a potted plant, but after a day of strenuous and soulless exertion, they cannot stand the idea of returning to an empty house.

As with most ferociously ambitious individuals, especially those who pine for the dot-com IPO pillaging of the late 1990s, Kibble Ghosts appreciate a cat's sociopathic edge. Cats know what they want, and they really don't care about anybody else–Kibble Ghosts dig this. Every Kibble Ghost dreams of being whisked away in a private jet to start a new, tax-free life in the Cayman Islands. They take great comfort in the knowledge that if they never come home again, their cat could survive on the koi in their ornamental pond and, without further ado, find another leg to rub against and be equally pleased.

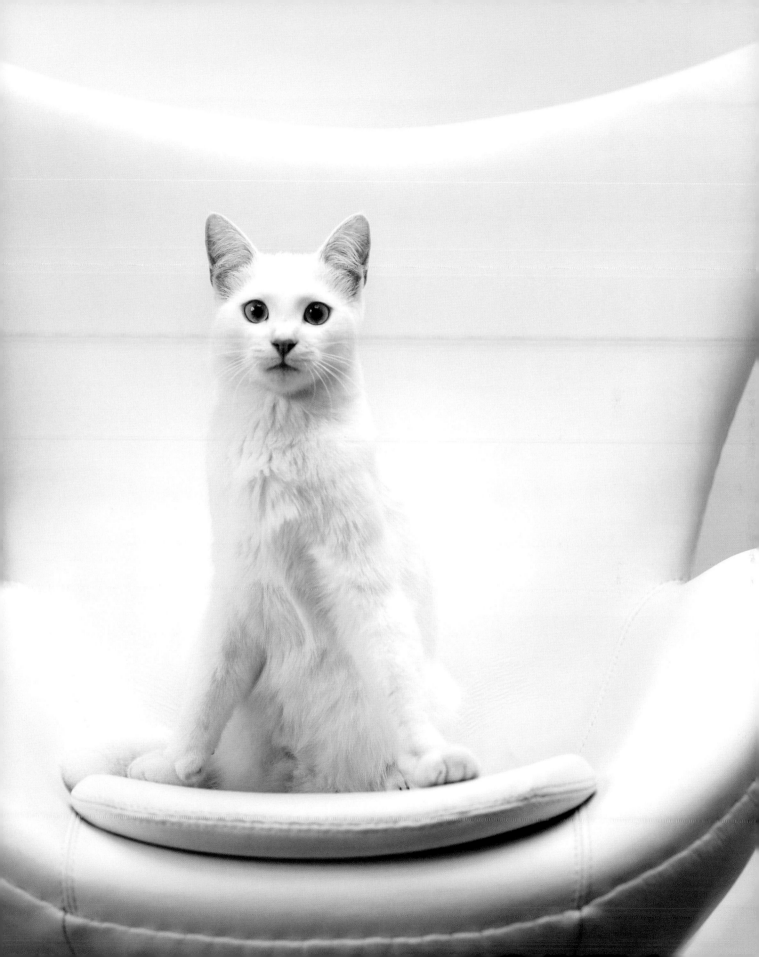

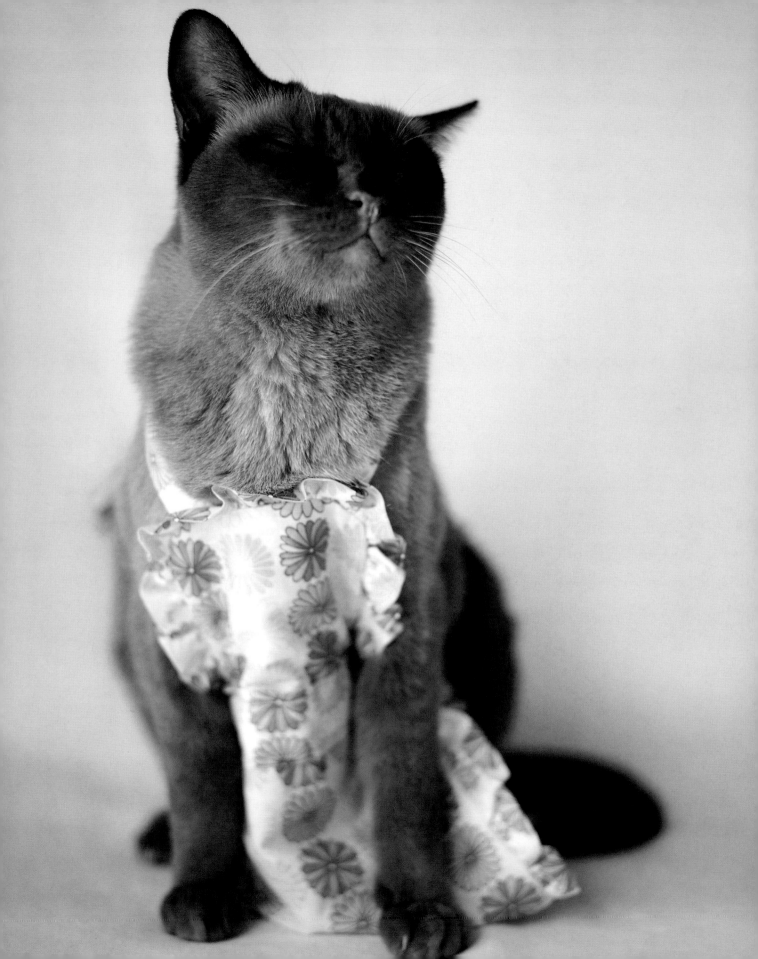

3 MOTHER TERESA CAT COMPLEX

The third subclass of cat lovers contains those who suffer from MTCC–a compassionate disorder, possibly glandular, that compels people to take pity on wretched, helpless creatures such as loser ex-boyfriends, homely colleagues who snort-laugh, and all manner of stray cats.

MTCC sufferers mean well, but they are always frantically running after other people and have very little time left for independent, rational thought. *Doormat* is too strong a word to describe them, but if you find a hole in your sock at two a.m., they will be standing by with a darning needle. It doesn't bother them that their pets won't do what they are told–nobody else listens to them, either.

When these worry-worn, kindhearted souls stumble home to their little sanctuary after a long day spent fixing everyone else's lives, they just look forward to savoring a microwave meal while watching their favorite prime-time hospital drama. The last thing they need is a bright and boisterous pet that needs to be taken for a walk, played with, or generally fussed over. To have one largely mute and undemanding creature in their lives is an answer to their prayers.

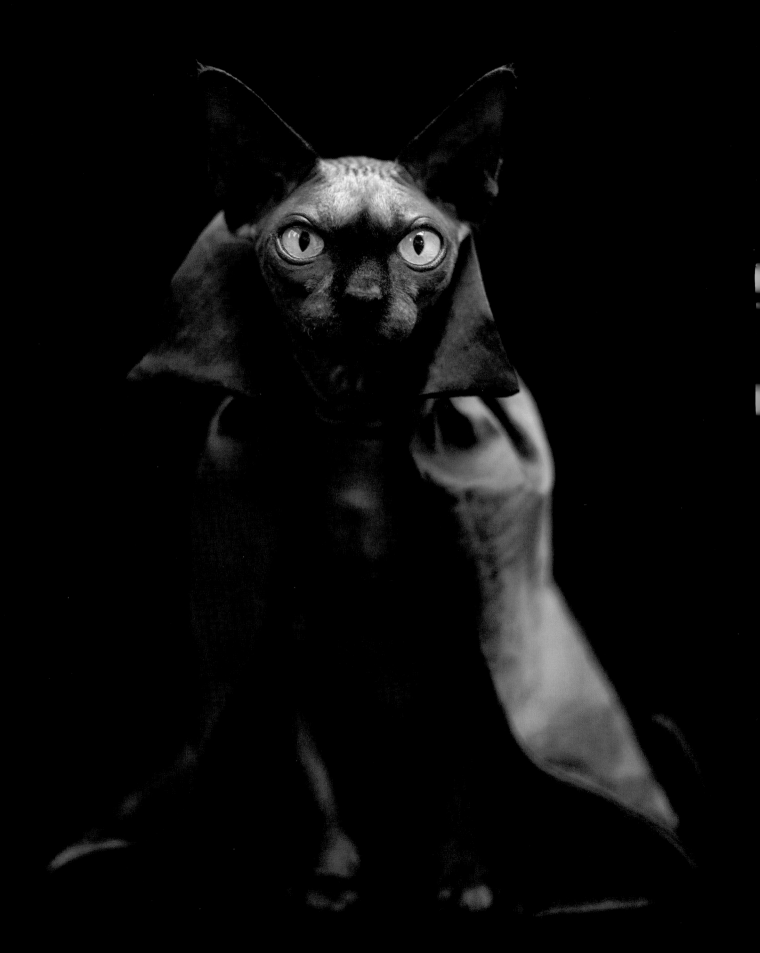

But not all cat lovers are pudgy, masochistic loners who lack the energy and self-respect to have a dog. Some are simply evil.

It's no surprise that throughout history, a faithless congregation has always been drawn to the sins of cats. One has to assume that pretty much all the cold war double agents were cat lovers.

The same goes for Brutus, Judas Iscariot, Benedict Arnold, James Wilkes Booth, Lee Harvey Oswald, James Earl Ray, Nathuram Godse, Lucretia Borgia, and Tokyo Rose—cat people through and through. Lady Macbeth, Lex Luthor, and Professor Moriarty, for sure.

And I can hardly imagine Lassie or Balto running into the arms of Dracula, or Dr. Frankenstein and his undead monster.[41]

I have no doubt that Jesus loved cats, too, but I'm quite sure he favored dogs.[42] Which is probably why dogs have always been the pet of choice for poets, kings and queens, true heroes, and every adventurer worth his boots. Canine courage, loyalty, perseverance, selfless love, and complete honesty place dogs at the center of many noble lives that shaped history.

Homer tells us that when Odysseus finally returned home to Ithaca after decades at war and at sea, only his true and faithful dog Argos recognized him. According to the Arthurian legend, King Arthur had a dog named Cafall, of a mighty breed so noble and brave that only a king as courageous and just as Arthur himself could ever be its master. William Shakespeare's affection for dogs saw him slip them into half a dozen of his famous plays.[43]

In the right circles it's well known that Abraham Lincoln had a poodle and that JFK stroked a Welsh terrier named Charlie during the Cuban Missile Crisis to help him stay calm. Paul McCartney wrote a Beatles hit inspired by his dog Martha, and ironically, Dr. Seuss, creator of *The Cat in the Hat*, much preferred dogs.[44] Other celebrated philocynics include Sigmund Freud, Helen Keller, Sir Isaac Newton, Fyodor Dostoevsky, E. B. White, and John Steinbeck.

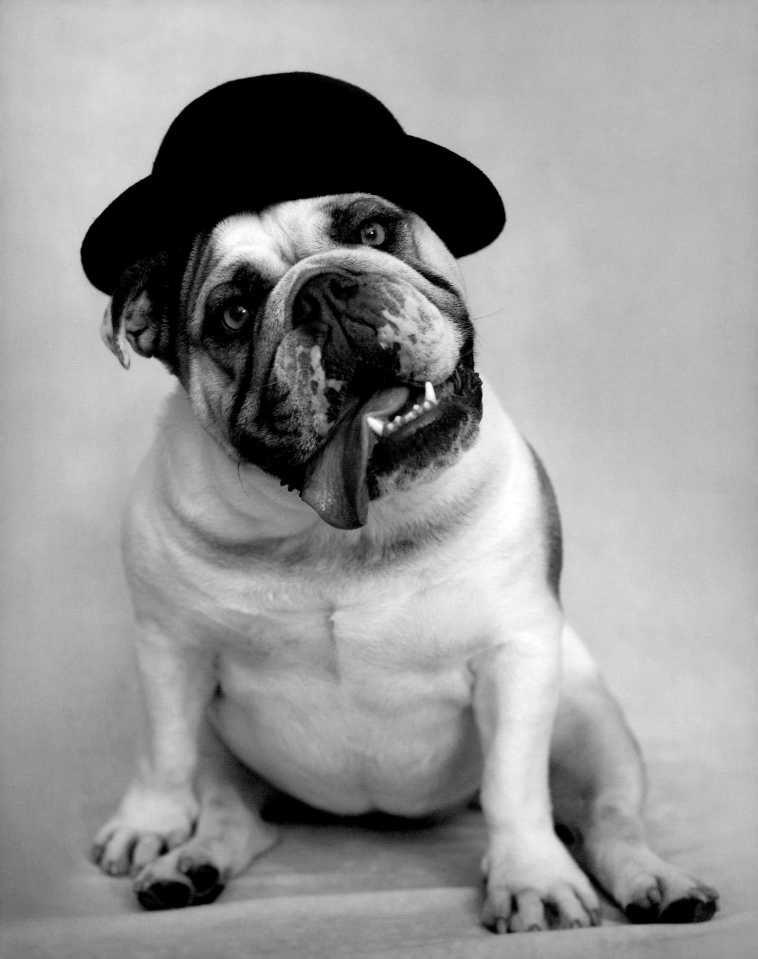

Florence Nightingale used her pet dog to help heal the sick and injured, Audrey Hepburn adored Mr. Famous, her Yorkshire terrier,[45] and Amelia Earhart's trusted guard dog was named James Ferocious.

Australia's boldest outlaw, Ned Kelly, was a dog lover, and who could imagine the greatest Briton, Sir Winston Churchill, without his tenacious bulldog stumping down the street beside him, their jowls quivering in unison.

Of course, the repellent exception to the long list of talented and revered dog lovers is that, shockingly enough, Adolf Hitler also had a dog—a sweet tempered German shepherd named Blondi. However, if truth be told, Blondi was presented to Hitler as a gift,[46] and in the end, the vanquished Führer force-fed her a cyanide capsule to see if the fabled poison was really as lethal as everyone claimed. It was.

One can only imagine how much better the world would be if more people had enjoyed the company of a decent dog early in life.[47]

Might we, the depraved descendants of Adam and Eve, still be enjoying the vegan nudist utopia of Eden had the original couple sought an honest dog's second opinion about the lies lisped to them by the glittering serpent?

Probably.

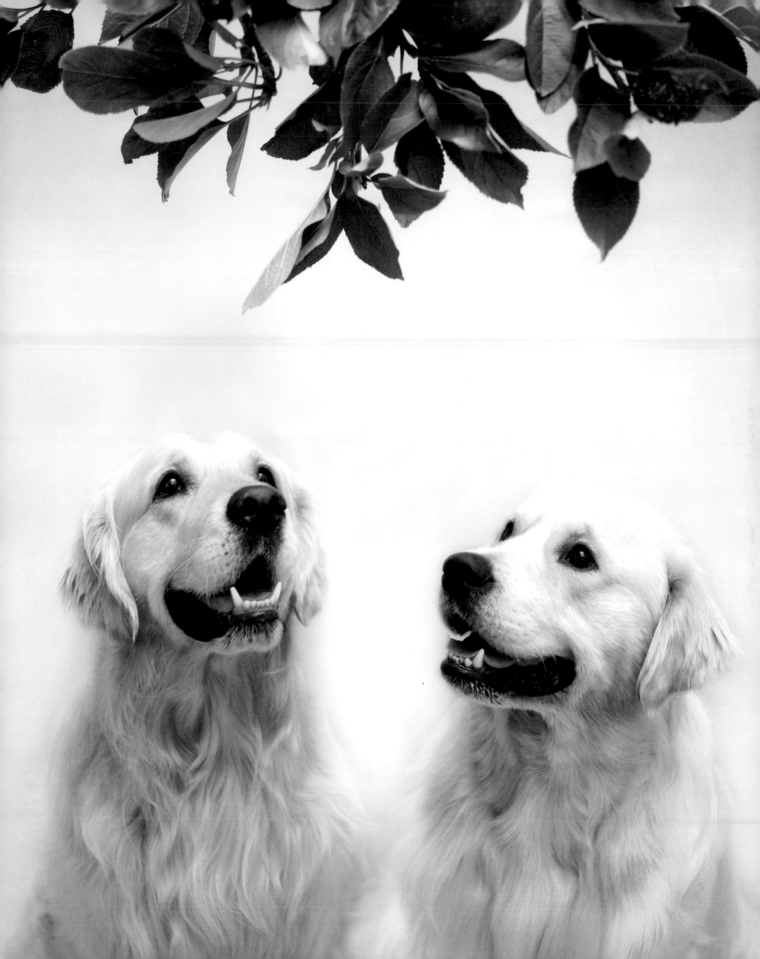

Would the Israelites have escaped bondage in Egypt much faster if they had not been at least partially indoctrinated into cat culture?
I say yes.

Would Russia have won the Space Race and beaten America to the moon if Sergey Korolev had been a cat person? No. Not a chance. But it would have been highly amusing to watch seriously stressed Soviet scientists unravel while trying to train the uncooperative cat cosmonauts.

The Pet Rule of Thumb is this:
Good hearts love dogs, and dogs love good hearts.

Owning a dog encourages an active, gregarious lifestyle and has been shown to enhance important social skills, increase self-esteem, inculcate a sense of responsibility and compassion, help make new friends, and reduce childhood obesity.

Conversely, cats are nature's way of saying, "Whatever."

That cat owners overlook so many disturbing traits in their pets further draws their own character into question. Ultimately, such conditioned blindness proves only that, like actors and models who are given far too much credit for intelligence and morality, cats have taken cute and cuddly just about as far as it can possibly go.

Dogs are gifted judges of character. They instinctively know who to trust and, with few exceptions, take an immediate dislike to shifty, unpleasant people.

Cats, however, cannot distinguish between an ax murderer and a flying nun, and they are as likely to adore and attack both at any given moment.

It is primarily for this lack of discernment that cats were always assumed to be the preferred company of malevolent witches,[48] James Bond supervillains, and foul-breathed felons. When you consider the cat's penchant for malicious skullduggery, it's easy to see why. Not to mention their unsettling habit of cavorting in the shadows like caffeinated demons at times when Boy Scouts, corn-fed chickens, and trustworthy dogs are fast asleep.

Far be it from me to suggest that a great number of cat lovers are simply people whom dogs do not like. But the evidence is certainly out there.[49]

Cats are not without their charms

Though it is galling to acknowledge, our lives are richer for the existence of cats, if only because they and their feeble champions make an amusing counterpoint to the wholesome world of dogs.

Cat shapes, cat movements, and cat tastes, though often bizarre, are irrefutably intriguing and quite pleasant to observe.

Cats may have virtually none of the dog's positive attributes, but then, they also have very few of the dog's negative traits. They don't bark, slobber, or jam their snouts into the unsuspecting loins of your guests. At least, not the cats I have seen.

CATS ARE CHEAP TO FEED AND HOUSE, AND THEY DON'T REQUIRE A LOT OF SPACE.

They also live longer than dogs.

Compared with dogs, cats offer a comfortable low-effort/low-yield symbiosis. Beyond tolerance and gentleness, not much else is required to look after them. You don't have to play with them too often because cats are their own best friends and will just as happily amuse themselves with whatever is lying around.

You needn't raise a sweat training your cat because such attempts almost always prove futile. By all means, try to offer your cat a stimulating range of games and challenges; however, most efforts to improve their lives in any way will usually be ignored. Rest assured, if they ever want your input, they'll let you know.

The cat's unwavering predilection for self-absorption allows its owner to indulge in similarly vainglorious preening. A perfect companion for the budget diva and the modern metrosexual man.

You don't even need to like your cat very much.

Whereas dogs can become nervous wrecks in a chaotic or hostile house, cats seem to actually enjoy an environment of mutual loathing. It is in their nature to walk on eggshells at all times anyway and, provided that shouting is kept to a minimum and no one steps on their tails by accident, cats quite like observing the drama of domestic conflict from a safe vantage point.

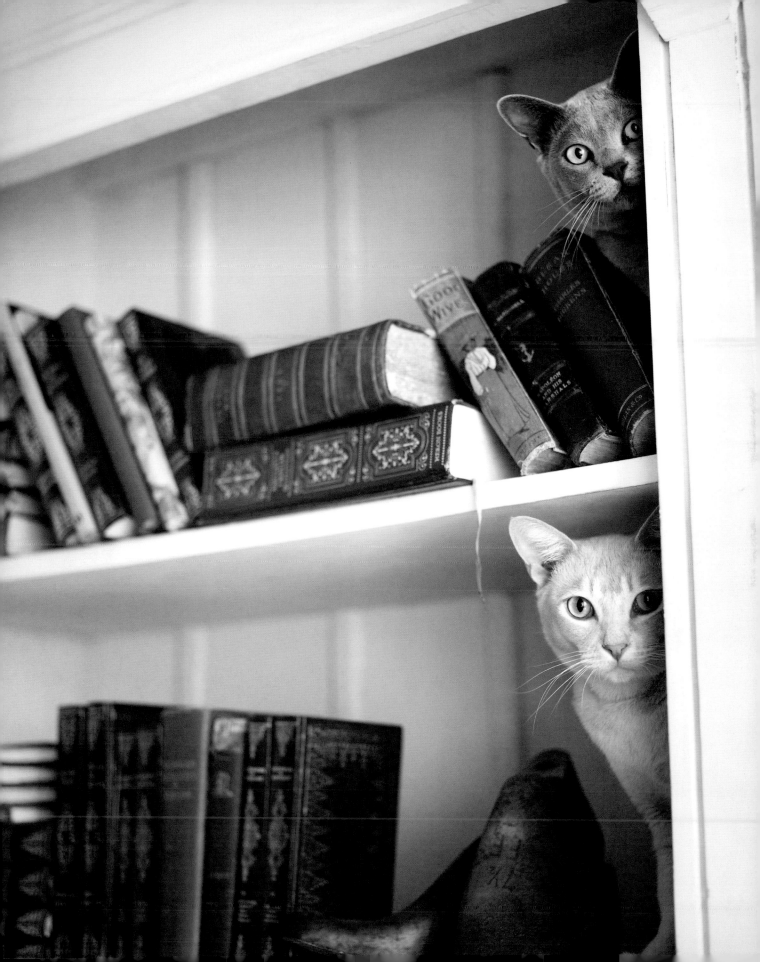

One bonus of owning cats is that sometimes they use their natural hunting abilities for good.[50] Despite their relatively fragile frames, cats have proved useful for eradicating huge numbers of pestiferous rodents throughout the world.

Of course, buying a cat to catch mice is like buying a goat to keep the weeds down. Maybe it will, and maybe it won't. Just as the goat may chomp on all your prize-winning orchids, a cat may decide it would much rather maul your curtain tassels.

There have been some legendary "mousers."[51] Of course, truth be told, many cats are terrified of rats and mice. For anything bigger or more menacing than a bloated gerbil or an asthmatic hamster, you need a fearless little terrier.

Despite their fabled curiosity, cats are completely uninterested in the needs of others and, so long as their basic desires are met, are content to keep their own company and pursue their own pleasures.

As such, they are not really a pet according to any reasonable definition—they are more akin to a kinetic sculpture with sadistic tendencies. A cat lover is, in effect, a collector of living art.

Cats are ideal cohabitants for the millions of lazy, busy, or inert people who clog the arteries of humanity.

In terms of companionship they ask for very little and offer only slightly less. The sum total of pleasurable cat experiences includes a toasty lap and quiet hours ruptured only by random berserker acts of titillating madness. True, the same could be said for a hot-water bottle and a large beetle tied to a length of cotton thread.

NEVERTHELESS, CATS ARE ATTRACTIVE TO LOOK AT AND, WHEN POSSESSED BY THEIR OWN FRISKY DEMONS, HILARIOUS TO OBSERVE. [52]

Although often cold and furtive, cats can become extremely cuddly critters when the mood takes them. Their muffled purring warms the heart, and their plush fur is a delight to fingertips.

I hate to admit it, but there is something strangely compelling about their pompous conceits and counterintuitive mannerisms.

Being warm, soft, and sleepy encompasses all the very best qualities of any cat.

And while this pales in comparison to the virtues of dogs, truth be told, it's an almost irresistible combination.

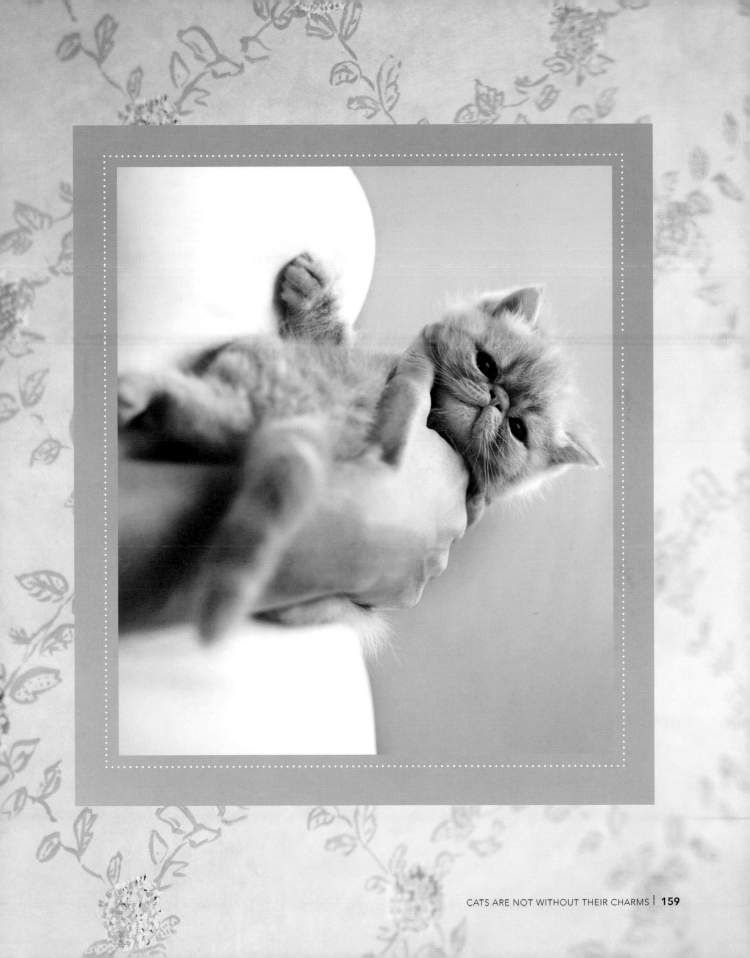

In praise of dogs

The basic reason why dogs get along with people and can be trained to do so many amazing, difficult things while maintaining their good humor is that dogs simply adore us and want to be near us and help us in any way they can.

Dogs exalt in our company. They also really like being dogs and thus delight in their natural abilities and in discovering new skills, and nothing pleases them more than to demonstrate their talents for our benefit.[53]

Dogs are everything we wish we were, embodying the kind of selfless, tireless, and cheery benevolence that we would like to think we would offer to all we meet, and conversely, wish was constantly directed toward us by other people.

The debt that the human race owes dogs is impossible to overstate.
Our shared history speaks volumes for the dog's unselfish service and
unwavering loyalty. When footwear was just a crazy idea put forward by
primitive yuppies, dogs walked beside mankind and did everything they
could to help put mammoth steaks on the table.

Dogs have helped us hunt and gather food and care for our flocks.

**Dogs have helped us
explore our world,
and our universe.** [54, 55, 56]

They protect us, those we love,
and all that we treasure.

They look out for us.

Dogs will always be there for those in need.

The heroic actions of dogs are the stuff of legend.

Can you even imagine a cat saving you from drowning?

How about dragging you out of a burning building?

Or digging you free from an icy avalanche?

I DON'T THINK SO.

Cat's don't rescue anybody—they just get rescued. And they never ever say, "Thank you."[57]

The downside of dogs

Dogs may make perfect pets, but that doesn't mean they are perfect.

Owning a dog is a lot more work than owning a cat. Cats operate as largely independent life-forms within the climate controlled ecosystem of your home.

Dogs, however, are true dependents. Their well-being is entirely in your hands. Everything they need and want consumes your time and energy.

Like well-adjusted children, dogs require significant training and supervision. They must be fed, watered, and exercised every single day. They need love, lots and lots of love, and they need to know you are there for them. In other words, caring for a dog is not a hobby or a part-time responsibility—it's a real relationship.[58]

Dogs can get into all sorts of trouble, whether you do a good job of caring for them or not.

They can be needy and when left alone too long, they may become anxious and fret. While you were out, they may have been driving the neighbors crazy by barking for hours on end. Or they may have gotten bored and demonstrated their displeasure by being destructive.

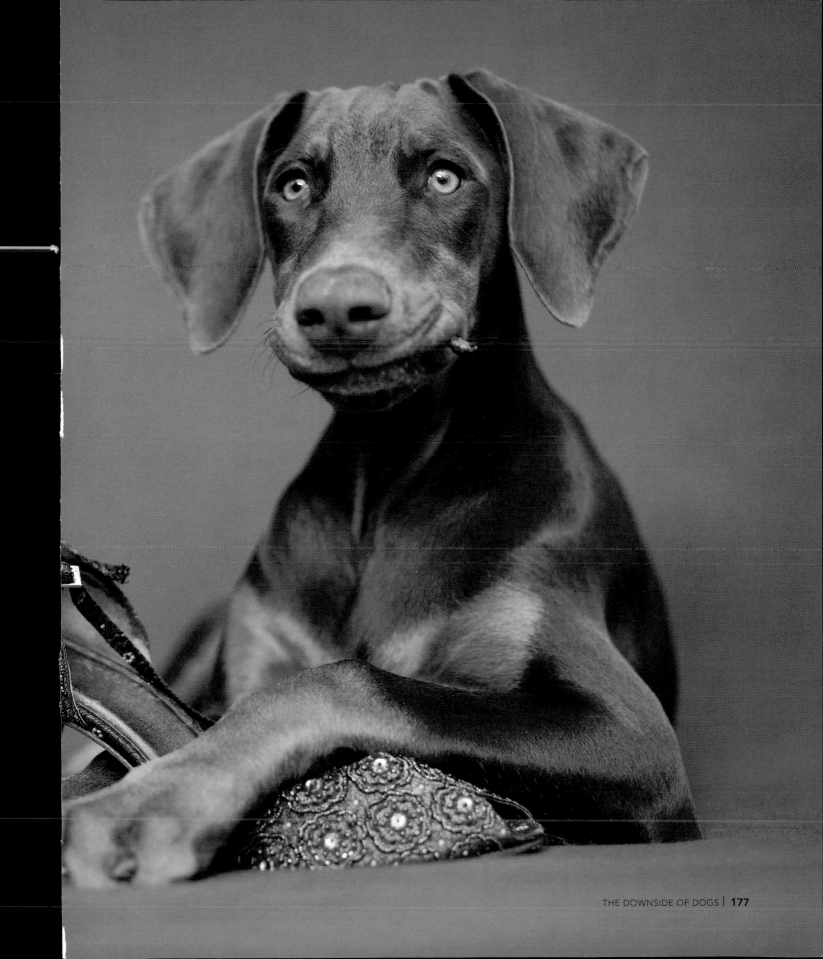

Cats can create carnage if they so choose. But even a happy dog makes more mess than an unhappy cat. Particularly when they try to march the yard into the living room.

Dogs haunt the kitchen, dining table, picnic blanket, and barbecue grill like slobbering, sausage-stealing poltergeists.

The world is their restroom.

Miserable dogs get upset and run around breaking stuff.

Joyous dogs get excited and run around breaking stuff.

From time to time, they keep everyone awake by howling at the moon.[59]

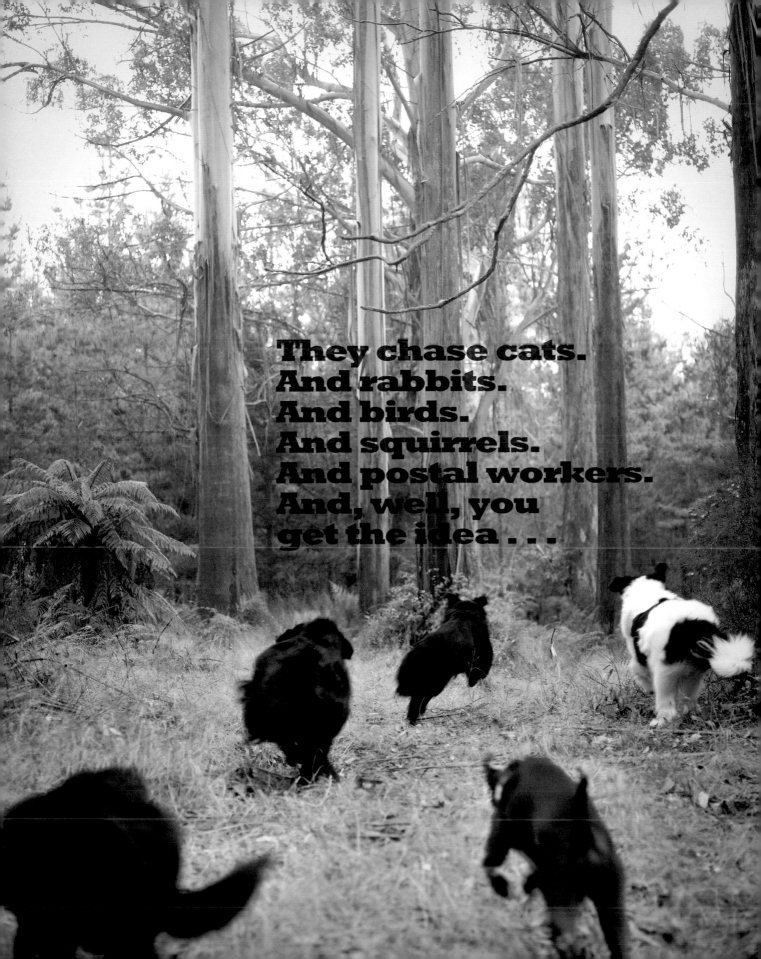

They chase cats.
And rabbits.
And birds.
And squirrels.
And postal workers.
And, well, you
get the idea . . .

**Dogs fight other dogs.
And, every now and then,
dogs bite people.**[60]

There is no doubt that dogs represent greater potential danger than cats,[61] but it's important not to get carried away about this fact because the greater truth is that dogs are also far less dangerous than people.

Indeed, if a perfect safety record was the only issue in determining pet choice, then no one would have dogs, cats, rabbits, guinea pigs, chinchillas, turtles, parrots, or ponies because all have the capacity for inflicting actual bodily harm.[62]

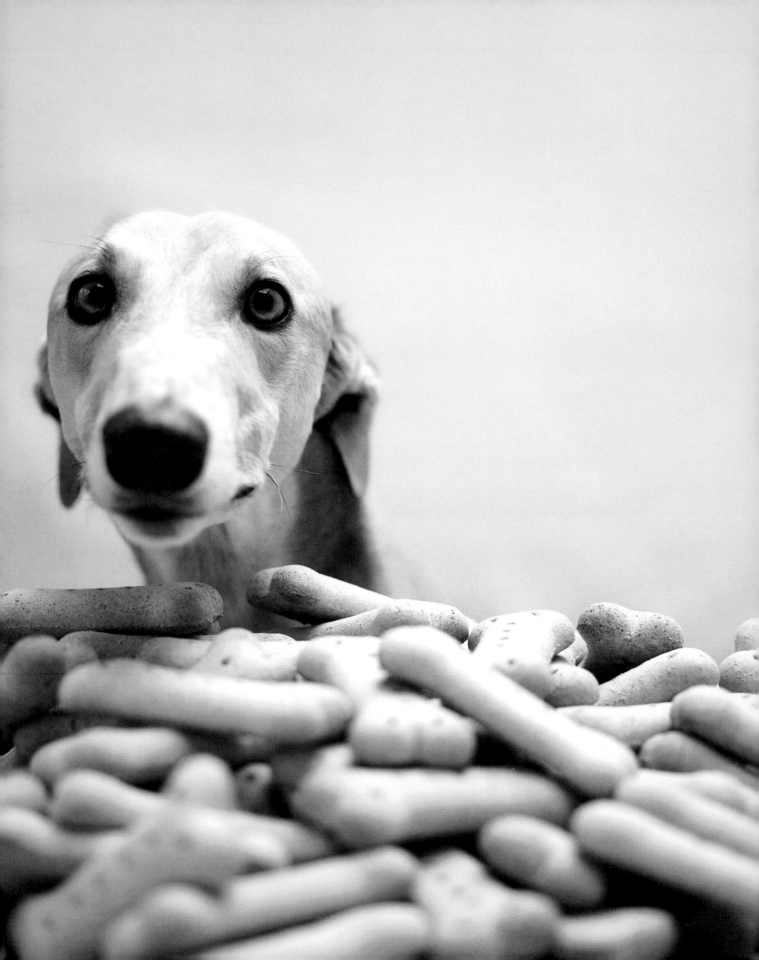

Dogs are also more expensive to look after than cats. For starters, they eat a lot more.

Boarding is also significantly more costly, and bedding, toys, and visits to the vet aren't free, either. According to veterinary and pet industry surveys, dog owners spend more than twice the amount on their pets' health and well-being than cat owners.[63] These figures do not represent pricing disparities or suggest that dogs are more prone to health problems. Instead, they represent further proof of the higher regard people have for dogs.

Cats get sick, too. But because they live their own separate lives and have limited means of communicating their feelings clearly, their needs often go unnoticed. Dog owners, by virtue of their close connection, are far more in tune with their pets' needs, and thus they go to far greater lengths to ensure that their best friend is happy and healthy. Indeed, many devoted dog lovers would rather go without themselves in order to provide the very best for their dog.

One of the saddest things about owning dogs is that their life spans are undeservedly short. Most dogs don't live longer than about twelve years. Some, especially the giant breeds, don't even live past ten.

After all the time, energy, and love you invest in their well-being and all the wonderful and difficult times you've shared, the hardest thing you will ever have to do for your dog is say good-bye.

The best and worst thing about dogs

A dog's love is expressed as loyalty, and this is not an easy concept for cat people to understand because the cat equivalent of loyalty is merely recognition.

True loyalty is trust and devotion born of friendship and respect. Dogs believe in us, not because to them we seem like gods,[64] but because we are their family; thus they believe they can always count on our unconditional love.

How could such adoration and devotion ever be a bad thing? Because so many dog owners are unworthy of it. We are shamed by our dog's loyalty, and we know, deep in our hearts, we will never measure up to it. In a fractured, impersonal world like ours, such a precious gift should be treasured, and yet so many of us take it for granted. Worst of all, we turn it against our dogs, repaying their loyalty with mistreatment and neglect.

Dogs will do absolutely anything for those they love. They will endure any hardship and face any peril. They would fight to the death to protect their extended family from harm. Primal fear and mortal wounds cannot dissuade them from their ferocious fidelity.

A dog would follow you to the edge of the world,

but anyone who has tried to put kitty in a pet carrier for a six-minute car journey knows that cats ain't going nowhere for nobody.

Of course, there is an especially deluded wing of cat militants who declare dogs are stupid for showering their affections on unappreciative chumps like us.

After all, they figure, a dog's joyous tail-wagging, unfettered devotion, and excited wiggles of welcome, no matter how badly they are treated, can only be evidence of inferior intellect. A good point—to which I respond, "An idiot says what?!"

A dog's demonstrative behavior, far from indicating any inability to reason, is a measure of their enormous compassion, optimism, hope, and a capacity for forgiveness that should leave us all withered with shame.

There is almost nothing you can do to break a dog's heart. Almost.

You may offer dogs nothing but a cold floor to sleep upon. And they will stay.

You could leave dogs unfed, unwatered, and unwashed. And they will stay.

You may shout at them, cuff their ears with curses, and deny them any form of affection. And they will stay.

You can beat them with sticks and break their bodies with stones and boots. And they will stay.

A dog will stay and stay and stay until your chest bursts open and the devil himself jumps out.

And only then, believing in her heart that she somehow wronged you, let you down, failed the family, and thus brought this vengeful battering upon her own head, only then will she slowly and reluctantly limp away.

The next time you see a stray dog in the street or in a rescue shelter, just stop and think about what it took to drive her away from her home. There is no living creature on this earth who is more entitled to your love and compassion.

A breed apart

It's not that dogs are in any way better than cats—dogs are better than cats in every way. So much better they are in a luminous league of their own.

Dogs inspire us to be better than we are, while cats demonstrate the basest of instincts, languidly strolling through each of the six remaining deadly sins whenever they can briefly overcome sloth.[65]

Dogs teach us patience.
Cats test our patience.

Dogs show us true courage.
Cats demonstrate the questionable virtues of cowardly survivalism.

**Dogs give and give and give.
Cats are the gift that keeps on grifting.**

**Cats want to be the center of your universe.
Dogs just want to share your world.**

There are wild places, and there
is our modest domestic realm.

Dogs have chosen us.
Cats have chosen neither.

The bottom line is this:
Dogs want love.
Cats want fish.

Dogs offer us such vast amounts of help and happiness and yet seek almost nothing in return.

They are just glad to be with you. The smallest gesture of kindness generates a disproportionate outpouring of affection.

To a dog, every morsel is a feast. Every kind word, a symphony of delight. Every pat, a thunderclap of joy.

In their minds, every time you go out for a walk together you are ascending the steps toward heaven.

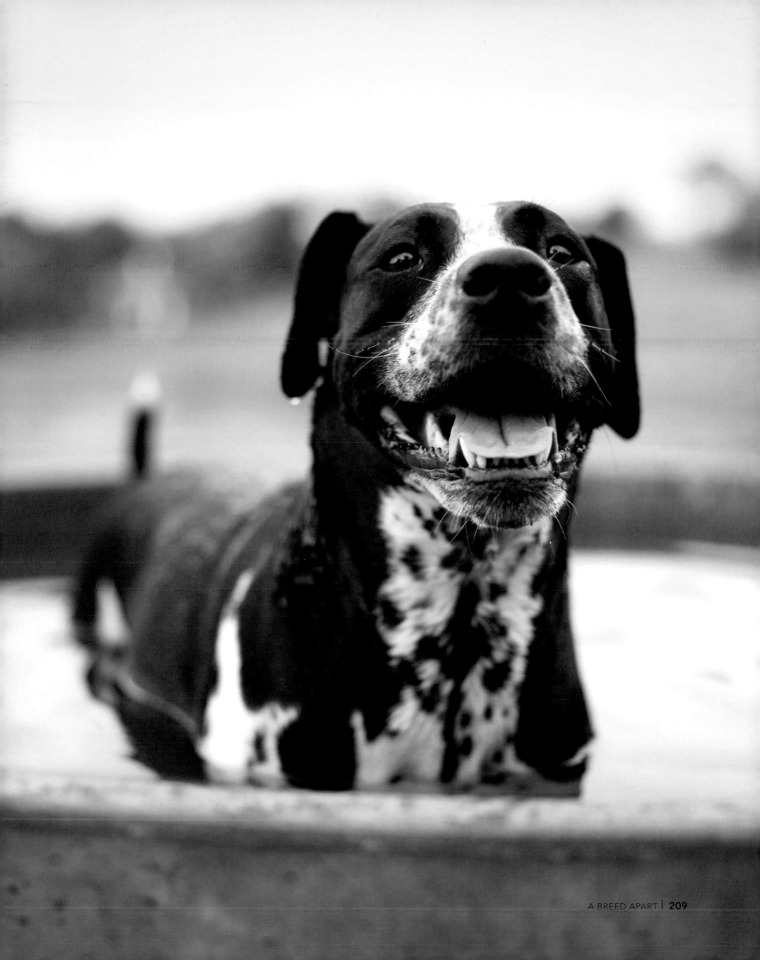

Life without dogs is too awful to contemplate. I really don't know what would happen to the future of humanity without the dog's example of unconditional acceptance, eager support, and joie de vivre, but I suspect a great emptiness would open up where love and hope used to be.

Though you may not realize it, much of what makes civilization work begins and ends with love and hope. The wheels of steel may continue to turn, but without our faithful friends, the modern world and all its marvels could not prevent the collective human heart from grinding to a joyless halt.

So let's be brutally honest. In comparison to dogs, cats bring almost nothing to the table, and that which they do bring, we could probably do without. Dogs are clearly the only pet anyone could or should ever want or need.

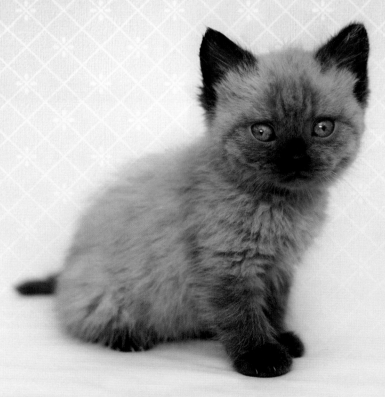

If cats suddenly vanished from the face of the earth, would anyone really miss them?

Well?

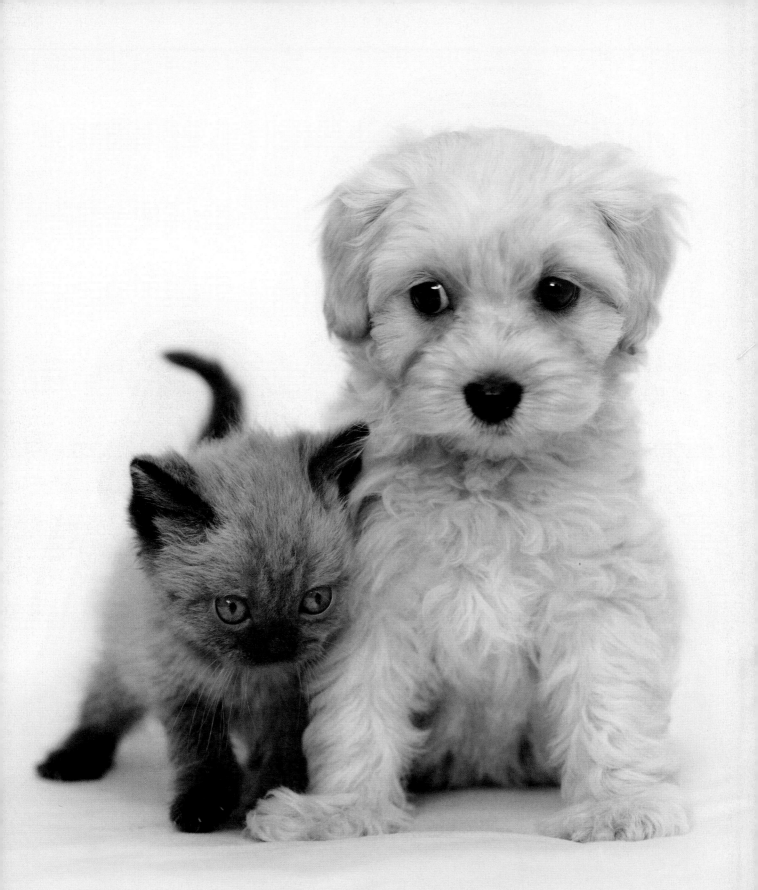

Okay, maybe, just maybe, there is still a little something to be said for soft, warm, and sleepy.

But of course, only a dog would ever be big enough to admit that.

Epilogue

I'M NO CHAMPION OF SOBRIETY. Nevertheless, I advocate clearheaded caution as we swim into these penultimate pages, where reading rapture is known to take full and dangerous effect. No doubt, having just enjoyed the literary equivalent of a lemonade enema, you're exhilarated and feel moved to rush out and buy a dog, or perhaps redraft your legal will to include a nebbishy guardian for your cat before faking your own death and then buying a dog. It's only natural. And there's no reason you shouldn't go ahead with your plans, just so long as you take a moment to think everything through.

Life tends to be more complicated than we'd like. When I set out to be a writer, I believed the essential characteristic of the great nineteenth- and twentieth-century novelists was sideburns.[66] Turns out there is a little more to it. So, too, choosing and caring for a dog is not quite as simple as it sounds.

For starters, not everyone should have a dog, no matter how much he or she may want one. House-proud perfectionists, for example, should opt for a designer throw cushion instead of a pug.[67] And creepy Internet hermits should stick to iguanas, lungfish, scorpions, tribbles,[68] and other immobile and impassive creatures for whom quiet excretion marks the high point of their day. Bringing a dog into your home is a profound commitment and, as Elizabeth Taylor will tell you, love is not enough. A happy, healthy dog is the joyous result of time, effort, expense, and inevitably, a certain amount of heartache. With that in mind, here is a six-point checklist to chew on before you carry a puppy over the threshold and into your life:

1. The Big Question: Why do you actually want a dog? Dogs are not toys, machines, or weapons, and should not be acquired merely to amuse children, scare away Jehovah's Witnesses, or start conversations with attractive single women (alas, I've tried). Yes, dogs can offer a sense of security and be helpful in many ways, but if your reason for getting a puppy goes beyond having a fun, active companion animal for the next ten years or so, then you'd best reconsider.

2. Time: How many spare hours do you have each day? The number-one prerequisite for owning a dog is having enough time to look after it properly and enjoy its company fully. Quality time means a lot more than just scooting outside for walks before and after work.

3. Your World: Do you live in a dog-friendly environment? No matter how hard you try, dogs will always create some degree of mess, odor, and noise, and this has to be okay for everyone. Even fluffy, little laprats need enough space to live and play comfortably, and easy access to safe outdoor areas is also vitally important.

4. The Cost: Proper pet care generates real expenses that have to be included in your budget.

Don't kid yourself—you will be making sacrifices. Even without medical emergencies, you'll find that basic bedding, housing, toys, leashes and collars, vet bills, boarding kennels, and license/registration fees quickly ring up a pretty hefty tab. And the bigger the dog, the bigger the food bill. My beloved Great Danes basically built the local butcher a beach house.

5. Effort: Looking after a dog means being busy and active. As far as your dog is concerned, you're the live-in manager of a combined hotel-school-gym-hospital-spa-playgroup-restaurant that is open 24/7.

6. Lifestyle: From snoozy sofa muffins to tireless hunting dogs, you must decide what kind of dog best suits your personality and the way you live. Travel is a factor, too—your dog doesn't stop needing care and attention when you're not around. You'll do a lot better if you choose a dog breed based first on what they need and how they behave, not just on how they look. Here's a free tip: Greyhounds and walkers don't mix.

Having considered these factors and made your choice, please do the right thing and buy your dog from an ethical breeder or a shelter. Don't support putrid puppy mills or seedy pet shops where inbred, mistreated dogs are stuffed into tiny cages—and never, ever buy a puppy online.[69] I make it a policy to always meet the breeder in person, inspect the kennels, and spend a little time with the mother and father of the puppy I'm considering. If a breeder won't let you do all this, then do not buy a dog from him—clearly, there is something to hide. And please consider adopting a shelter dog. In fact, this should be your first stop. Dog shelters are a great place to see an enormous variety of breeds as well as magnificent mutts you couldn't even imagine. You'd be amazed how many wonderful puppies and dogs, including stunning purebreds, are waiting in shelters to fall in love with someone like you. The best part is that if you choose a shelter puppy, you'll save money and a life.

Finally, remember that caring for dogs doesn't end with your pet. Always report abused or aggressive dogs to the police immediately and donate whatever time and money you can afford to local animal shelters and leading international organizations such as the Society for the Prevention of Cruelty to Animals (SPCA).[70] Your ongoing support makes it possible for these people to care for animals in need, so please give generously. Every dog deserves to be as lucky as yours.

BRADLEY TREVOR GREIVE

Notes

1 I know, I know. Like there's any other kind . . .

2 The survey doesn't actually tell us whether these people were miserable to begin with or whether the cats ruined their only chance for happiness.

3 While I am rubbing it in, dog owners are more likely to be active and healthy, have more friends, and look totally awesome in tight jeans.

4 The only reason cats don't already fill every field of view is that their petite stature, velveteen veneer, and unholy elasticity enables them to squeeze into every tiny nook and cranny like a boneless squirrel.

5 If you can't imagine how one tiny kitten could make the slightest difference, you may wish to view Monty Python's 1983 musical comedy, *Monty Python's The Meaning of Life*. Please pay close attention to "Part VI: The Autumn Years," where Mr. Creosote (played by Terry Jones) accepts a wafer thin mint from a French waiter (played by John Cleese). Then have a good long think.

6 "Cat Blanket Theory" (CBT) is a little bit like the "Gray Goo" problem that keeps nanotechnologists awake at night–but with razor-sharp retractable claws.

7 Fortunately allergies, respiratory problems, skin conditions, sunlight aversion, general apathy, and high dry-cleaning costs keep this potentially dangerous movement in check.

8 This conservative estimate applies only to registered pets. God only knows how many free-range feline forms peel themselves out of alleys and gutters at the witching hour and sweep through shadowed streets like a bloodthirsty breeze, gathering parasites, spreading disease, and tearing the unblemished souls from the hearts of tiny birds, innocently sleeping in their familial nests like feathered angels. But I digress.

9 At least by me, anyway.

10 Or, to put it another way, every century gets the blonde it deserves: the sixteenth century had Queen Elizabeth; the seventeenth, Christina of Sweden; the eighteenth, Catherine the Great; the nineteenth, Marie Curie; and the twentieth, Marilyn Monroe. We have Paris Hilton.

11 Since the decline of Starbucks, the blogosphere has become the principal haven for the truly talentless.

12 *Populous* is probably the adjective these overreaching malapropists were groping for. Either way, they are quite mistaken, as pet birds and fish both outnumber cats and dogs combined.

13 An *ailurophile* is the proper name for a cat lover. The dog lover equivalent is *philocynic*. Try using these words in public–you'll feel smarter.

14 Though cat lovers don't often know how, where, when, or why such cat worship took place, they are generally referring to the Egyptian cat cult of Bast, which officially ended in AD 390.

15 Other odd religions have incorporated human sacrifice, "reading" both the bloody entrails of chickens and cracked turtle plastrons, and the belief that walnuts contained magic power.

16 According to legend, it was the fanatical beliefs of Bast cult members that caused the Egyptian empire to fall and brought the glorious reign of the pharoahs to a humiliating end. At the battle of Pelusium in 525 BC, the Egyptian army was thoroughly defeated by the Persian conqueror Cambyses who instructed his soldiers to attach live cats to their shields–thus preventing any attack by the Egyptian warriors who fled the battlefield rather than risk wounding their sacred felines.

17 Numerous other animals were mummified, too. Interestingly enough, the first step of the ancient mummification process was to remove the deceased's brain by pulling it out through their nose using an iron hook. Considering the intellectual prowess of cats, this seems a most unnecessary exertion.

18 One such site, a Paleolithic tomb unearthed in northern Israel, revealed a dog and an elderly owner, forever clasped in a loving embrace.

19 Unless to do so is unavoidable, or at least slightly amusing.

20 Well, two. One for sure.

21 Perhaps not such a bad idea, considering NKOTB's 2008 comeback attempt.

22 Similarly, during that same chronological window, gerbils and amoebas may evolve to be smarter and more helpful than cats are now.

23 Depending on whom you ask, there are thirty to seventy-five different cat breeds. The higher number includes color classes and also entirely new breeds created by mating domestic cats with smallish wild cats. However, using the most generous definition, there are more than one thousand recorded dog breeds. It's pretty clear that in terms of variety, dogs win paws down (I fully accept that employing phrases such as *dogs win paws down* will not greatly improve my literary standing. However I derive comfort from the knowledge that Harold Bloom only takes issue with writers who are more accomplished than he is. To find out if you are on Harold Bloom's blacklist, contact him via the Department of English at Yale University by sending an e-mail to harold.bloom@yale.edu.)

24 Let's speak no more about this.

25 A cat can be fat or skinny, fluffy or sleek, in just a few combinations . . . Yawn!

26 And in recent years, dogs also defended their title against extraterrestrial life: alien microbes from Mars.

27 Celebrated actor and lothario George Clooney had a pet pig named Max and, interestingly enough, it was the one relationship that lasted. George and Max enjoyed eighteen long years of friendship before Max died of natural causes.

28 Cats have given curiosity a bad name. Though their snooping, sniffing, and prodding is often mistaken for extracurricular research, giving the noble impression of cerebral vigor and tireless inquiry, curious cats are in fact doing nothing more scientific than vegetative channel surfing.

29 A cat's personal space just so happens to be its owner's home.

30 Believe me, people have tried: In 1879 the postal service in the Belgian city of Liège undertook a bold experiment by engaging thirty-seven cats to deliver parcels of letters to the surrounding villages. It was not a success.

31 Dog lovers choose puppies based on how they will look and behave when they grow up, while many cat owners seem unpleasantly surprised when their fluff-ball kitten actually becomes a mature cat. Unlike dogs, cats don't change their behavior very much from one birthday to the next. And so the very same actions that made people laugh when they were cute little kittens can result in an adult cat being dumped at a shelter.

32 A human being might not find running and jumping so exhilarating and wondrous that they would spend all next day talking about it. Then again, a dog wouldn't chew someone's ear off at the water cooler trying to explain the oh-so-subtle genius behind an episode of *Lost*.

33 It's also possible that rampant catnip abuse has dulled the senses of an entire generation of "slacker cats."

34 Interestingly, on the rare occasion when a cat possesses unusually high levels of intelligence and an exceptionally agreeable personality, it is proudly described by its owners as being "almost like a dog." Almost, indeed.

35 Feel free to test this theory the next time you walk in the jungle or go to the zoo.

36 I strongly suggest you write down the phone number for the pound before you do this!

37 Truly demophobic cats even find their own fluffy tails as annoying as you or I would find a flatulent houseguest that arrives unannounced for dinner and stays for the weekend.

38 By the way, if a dog and their owner play fetch every single time they head to the park, this certainly isn't due to a lack of imagination on the dog's part.

39 My apologies to Walter Dean Myers and to Sharon Creech, who introduced his poetry to me.

40 Cat hygiene is wildly overrated. It's true that cats live mostly indoors and don't get as dirty as dogs who, as a rule, are more active and adventurous. But even shut-ins are well advised to make use of the bathtub from time to time. The reason cat owners don't bathe their pets more often is that bathing a cat is akin to washing the inside of a blender set on "puree." Nevertheless, cats need baths, just like the rest of us. I can't think of anyone I would want to get close to who said, "Soap? Bah! Never touch the stuff. But don't worry, I lick myself for at least an hour a day."

41 All the ghoulish geniuses prefer cats because they keep mice out of the laboratory and never get sick of eating brains.

42 Why else would *Dog* be *God* spelled backward? Oh yes, our Lord loved his little word games.

43 In *The Two Gentlemen of Verona* a dog features in one of the Great Bard's most hilarious scenes: the whimpering, tear-soaked parting of the clownish servant, Launce, from his stoic dog, Crab.

44 The far greater irony is that even though cats can be described as "eight pounds of Napoleon Complex zipped into a velour body-stocking," Napoleon Bonaparte himself loved dogs—no doubt as a result of his being saved from drowning by a fisherman's Newfoundland during his shambolic escape from the Island of Elba in 1815.

45 The svelte Ms. Hepburn shared her love of Yorkshire terriers with NFL iron man Brett Favre, Brazilian supermodel Gisele Bündchen, slim-hipped pop sensation Justin Timberlake, and high-profile soccer manager José Mourinho, who was arrested in May 2007 for refusing to give up Leya, his jet-setting Yorkie, to British police and quarantine officials.

46 Disgraced U.S. president Richard Nixon was also famously given a dog, a cocker spaniel named Checkers, indicating that you can never really trust someone who doesn't personally choose his or her own dog.

47 Still, I suppose it's just as well that, when unhorsed in the battle of Bosworth Field, the misshapen malefactor Richard III, didn't cry out, "A dog, a dog, my kingdom for a dog!" Had the tide suddenly turned in his favor the War of the Roses may still be in progress to this day.

48 Leading anthropologists and historians have discovered that many so-called evil witches, were actually highly intelligent and confident women whose advanced intellects and independent ideas made them targets of abuse by ignorant and fearful male oppressors. Having said that, please do not curse me or my dogs.

49 Having attended elite dog and cat shows, I have to admit that, at the most extreme level of obsessive devotion, cat and dog lovers are equally insufferable. Both look pretty stupid in the ring. Still, at least at the dog show you get to see the prized pooches strut their stuff—cat judges just look like they are examining a wig. Having said that, neither cat nor dog folk are as ridiculously pompous as horse lovers . . . maybe it's the jodhpurs and the silly hats.

50 Before you rush out and buy a living mousetrap, keep in mind that cats also seem to delight in killing legions of tiny creatures that no one in their right mind would ever want harmed.

51　According to *The Guinness Book of Records* the greatest number of mice killed by a single cat is 28,899. This impressive record belongs to a female Scottish tabby named Towser, who kept the Glenturret Distillery rodent population in check for over twenty years. I have visited Towser's memorial statue at the Perthshire distillery, which is conveniently located just outside the tasting room for the legendary Famous Grouse Scotch-Whisky, golden pride of the Scottish Highlands . . . mmmm, whisky.

52　Cats are fetching creatures but–and far be it from me to point out that Venus has an inverted nipple–while their glittering eyes can resemble warm gemstones, it has to be said their snakelike slit pupils give the cat's visage an occult goat-mask quality that is rather off-putting. In the least flattering light the split orbs deliver a thrilling glimpse of bright horror, akin to the realization that your knee is being caressed by a severed hand.

53　As sluggish, surly cats and Michael Jackson clearly demonstrate, there is a very fine line between self-love and self-loathing.

54　On November 3, 1957, after intensive training and great discomfort, a photogenic stray mutt from Moscow named Laika became the world's first astronaut. Laika, a quiet, clever, and by all accounts charming little dog, died from stress and overheating just a few hours after takeoff when the cooling system failed inside *Sputnik 2*. Her sacrifice paved the way for manned space flight and opened up the entire universe for her fellow earthlings. We should think of her every time we look at the stars.

55　"Laika" was actually a nickname meaning "Barker," which is the Russian name for the huskylike breed that Laika resembled in miniature. However, her real name, Kudryavka, meant "Little Curly," probably referring to her cute curly tail. Laika's other nicknames included "Little Lemon" and "Little Bug." But, of course, to many, especially most Americans, she will be forever known as the "Muttnik in Sputnik."

56　*Sputnik 2* was never designed to return safely to earth, making Laika the only astronaut knowingly sent to die in space. Her demise saddened millions of people and helped generate support for the modern animal rights and animal welfare movements.

57　Since we are on the topic, let's put the "My little Fluffy is descended directly from the Big Cats" myth to rest. This is nonsense. Domestic pets and big cats are only very vaguely related–they are not even in the same subfamily (*Felinae* and *Pantherinae* respectively). I mean, have you ever seen a tiger chased up a tree by a tea-cup poodle? Enough said.

58　This is somewhat true of cats, as well. The relationship may be weirdly one-sided and kind of embarrassing, but you still have to turn up.

59　Though frankly we'd all do well to howl at the moon from time to time.

60　Every year dogs seriously injure a lot of people, but the statistics never tell the whole story. Did the victims do anything to provoke, hurt, or frighten the dog, or was the animal told to attack them by another person? Not that there aren't nasty dogs in the world. There are. When I said there was a dog to suit every personality, I meant it. There are even dog breeds that suit vicious, sadistic jerks. But when you consider how often dogs are mistreated, it's actually surprising how few people are bitten.

61　The most foul-tempered cat can scratch an eye, bite a hand, cause nasty superficial wounds, and spread parasites. But beyond generating a cloud of allergies, that's pretty much it. Rumors about cats smothering babies in their cribs seem unfounded. There was one such incident reported in the *New York Times* about a hundred years ago, but it sounded suspiciously to me like the cat took the fall for an overwrought mother, and I could not find any recent case backed up by hard evidence.

62　The author, a former paratrooper, rugby player, amateur boxer, rock-lifting champion, and certified tough guy, has been sent to hospital twice for a critical allergic reaction to guinea pigs. Embarrassing but true.

63　FYI: Australians spend significantly more money on pet care than their government spends on foreign aid. Almost one billion dollars more, in fact. Mind you, indulging your pet with premium snacks, toys, and wacky luxury goods is not unique to dogs. Some folk buy tiny soccer balls for their goldfish to play with and little sleeping bags for their ferrets, which is cute but also kind of sad.

64　Trust me, dogs know that someone who occasionally wears the same underwear two days in a row or sings into a hairbrush is not a god.

65　In case it's been awhile since your last confession, the seven deadly sins are: pride, greed, lust, gluttony, wrath, envy, and the aforementioned sloth. In other words, the moral resumé for every cat to set sinful paws upon this earth.

66　Even George Eliot wore a handsome set of muttonchops, and Gertrude Stein sported a mustache that would have made any bare-knuckle boxer proud.

67　A.k.a., a wrecking ball of love.

68　If you even know what a tribble is, then you have no business owning a pet of any kind and also forfeit the right to human contact other than the accidental brushing of clammy fingertips when receiving change from pizza delivery guys. In terms of dog ownership potential, you would be utterly "tu'HomIraH," as your Klingon life coach would say.

69　Internet shopping is great for books, music, and novelty paperweights, but not for something so important and personal as a dog. Would you adopt a baby online?

70　The easiest way to make a difference in the lives of countless dogs is by making a donation via the official SPCA Web site: www.spca.com.